SUNSET COLONIES

UNIVERSITY PRESS OF FLORIDA

Florida A&M University, Tallahassee
Florida Atlantic University, Boca Raton
Florida Gulf Coast University, Ft. Myers
Florida International University, Miami
Florida State University, Tallahassee
New College of Florida, Sarasota
University of Central Florida, Orlando
University of Florida, Gainesville
University of North Florida, Jacksonville
University of South Florida, Tampa
University of West Florida, Pensacola

Sunset Colonies

A Visual Elegy to South Florida's Mobile Home Communities

Diego Alejandro Waisman

UNIVERSITY PRESS OF FLORIDA

Gainesville/Tallahassee/Tampa/Boca Raton
Pensacola/Orlando/Miami/Jacksonville/Ft. Myers/Sarasota

Pablo Neruda—"Si tú me olvidas," *Los versos del Capitán*—Pablo Neruda, 1952 y Fundación Pablo Neruda
"If You Forget Me" by Pablo Neruda, translated by Donald D. Walsh, from *The Captain's Verses*, copyright ©1972
 by Pablo Neruda and Donald D. Walsh. Reprinted by permission of New Directions Publishing Corp.
"Think You Can't Afford a Home? So Did They," *The Miami Herald* © 1980 McClatchy. All rights reserved.
 Used under license.
Published in the United States of America

29 28 27 26 25 24 6 5 4 3 2 1

Library of Congress Cataloging-in-Publication Data
Names: Waisman, Diego Alejandro, author.
Title: Sunset colonies : a visual elegy to South Florida's mobile home
 communities / Diego Alejandro Waisman.
Description: Gainesville : University Press of Florida, 2024.
Identifiers: LCCN 2024011399 | ISBN 9780813080734 (paperback)
Subjects: LCSH: Mobile homes—Florida, South—Pictorial works. | Mobile
 homes—Florida—Miami—Pictorial works. | BISAC: PHOTOGRAPHY /
 Photoessays & Documentaries | HISTORY / United States / State & Local /
 South (AL, AR, FL, GA, KY, LA, MS, NC, SC, TN, VA, WV)
Classification: LCC HD7289.62.U6 W37 2024 | DDC 333.33/8—dc23/eng/20240407
LC record available at https://lccn.loc.gov/2024011399

The University Press of Florida is the scholarly publishing agency for the State University System of Florida,
comprising Florida A&M University, Florida Atlantic University, Florida Gulf Coast University, Florida Interna-
tional University, Florida State University, New College of Florida, University of Central Florida, University of
Florida, University of North Florida, University of South Florida, and University of West Florida.

University Press of Florida
2046 NE Waldo Road
Suite 2100
Gainesville, FL 32609
http://upress.ufl.edu

For Alejandra, Sofia & Amanda

"Plum tree at my door, should I not return,
spring always will, you must bloom."

"Ciruelo de mi puerta, si no volviese yo,
la primavera siempre volverá.
Tú, florece."

—Japanese proverb

CONTENTS

Artist's Statement

Diego Waisman

Back at the beginning, when I visited the first trailer park community, I did so with much confusion. The people and spaces I saw were on the brink of radical change. Throughout the years, the displacement grew, and so did the archive of photos.

The photographs helped me to slow down the absence behind the new construction fences. A perimeter wrapped with stock images of eternal youth and happiness.

Eventually, the work found its root as a vehicle that crossed the boundaries between past and present.

I photograph the spaces that we inhabit as a reflection of the lives and stories embedded within every patch job, paint coat, and garden arrangement. I feel that the individual and the vernacular are perhaps the most telling aspects of identity and belonging.

Undoubtedly, this journey has become very personal. I believe it began unconsciously while listening to my grandparents' post-memories of displacement.

Although we can refer to much of my work as memory-inspired, I like to think of it as documentary in nature. It serves as a historical record of urban changes, which for the most part appear invisible.

While photography is merely another shadow inside the cave, I think that it allows for a focused experience intersected by representations. Sometimes, the stories we tell about places say as much, or more, about who we are and how we see one another.

Introduction

Amy Galpin

Photography can be a very intimate proposition. It not only serves as an analytical tool for the photographer but also a recording device of circumstances of any given moment. Photography also has a stillness that is hard to find nowadays. I like the fact that you can explore a complicated subject through images, which in turn also involves an emotional undertone without barriers and complicated language.

—Diego Waisman[1]

Diego Waisman's Visual Elegy

Diego Waisman makes pictures that address themes of social and economic displacement, exile, family, and identity. Born in Argentina, Waisman produces poignant photographs about his family members—portraying those who are nearby as well as those who remain far away. These personal works led to dynamic experiments with image and text as well as installations. His previous works include portraits of his daughter as well as installations that incorporate vintage photographs of his parents. This desire for domestic documentation evolved beyond his family to an urgent response to complexities of place and economic inflation in his adopted home of Miami. Furthermore, Waisman demonstrates his technical skill in his documentary photography of Patagonia, a region of expansive views and distinctive geographies. Across disparate series, Waisman synthesizes human resiliency and the enduring power of place.

Channeling influences from his own life and the allure of distinctive geographies, Waisman documents the dramatic and emotional socioeconomic shifts in Miami. The focus of his work during the last few years, exhibited as *For I Shall Already Have Forgotten You* and reproduced in this book empathetically relates gentrification and

the housing instability rampant in Miami. By highlighting economic vulnerability, the underappreciated joys of everyday life, and abstract sensibilities, Waisman creates a cogent and vital visual elegy for this contemporary moment.

Economic Vulnerability

Waisman has lived in Miami for many years, observing the economic hardships that many visitors to this sunny place miss during their temporary stays. Tourists often congregate in neighborhoods like South Beach and the Design District, while more marginalized communities remain in liminal, hidden spaces. In Miami, economic disparity becomes enhanced through environmental threats brought on by climate change. The frequency of hurricanes, the extension of hurricane season, and the ferocity of strong storms affect the livelihood of many who live in the city as neighborhood streets are flooded, property damage ensues, and individuals fear for their safety and their livelihoods. The longevity of the built environments and the individuals photographed by Waisman feels precarious.

Before the COVID-19 pandemic, Miami-Dade County's economic inequality was the second worst in "the U.S. as more than 14 percent of residents live in poverty, the ninth-highest rate among the country's large metros."[2] The onset of the pandemic further created economic stress as more people relocated to the city and local rents skyrocketed, but wages remained relatively the same. While economic shifts are experienced by residents across the city, those living in trailer parks adjacent to wealthy communities like Coral Gables experience threats to their livelihood. These local issues "mirror a national trend of trailer park owners selling their long-time investment to new investors who drive up the rent and eventually wipe the trailer park off the map, adding to a nationwide housing crisis where only 37 affordable homes exist for every 100 low-income renters."[3] While Waisman's work presents a regional crisis, these images resonate beyond a particular locale.

Many of Waisman's photographs in *For I Shall Already Have Forgotten You* delineate compressed spaces. For example, in one photograph new construction towers over a preexisting structure, an increasingly common sight in Miami. The upright hard-edge skeleton of the building in the background overwhelms the small white house with blue trim. Notably, the rounded hurricane shutters protect the house although from the appearance of the looming construction behind it, more protection is necessary.

Waisman describes the photographs in *For I Shall Already Have Forgotten You* as "evidence" of places neglected by society.[4] He ponders the advertising from decades past that cheerily offered a dream that does not exist today. By including examples of advertisements alongside his photographs, the artist draws a correlation between the historic commodification of trailer parks and the challenges encountered by many older adults who face housing insecurity without substantial financial savings. Waisman posits, "As Foucault mentioned, 'Old age is a deviance upon itself.' The act of not engaging in constant movement and enjoyment. I feel that these residents have run out of time due to the economic situation (inflation, stagnant social security, property process, etc.) and have been ignored and forgotten."[5] In these works, Waisman mines the American dream, in which the act of purchasing a house figures prominently. For many, acquiring a house and establishing a home remains a cornerstone of this aspirational American dream.

Other photographers have approached these complex issues of class and myth of the American dream. For example, Bill Owens's *Suburbia*, first published in 1983, focused on Livermore, California. Continuing Owens's tradition, Waisman employs keen observation, focuses on specific places, and allows the action to unfold before him as opposed to staging content. Waisman augments and enhances the ongoing archive of the cultural landscape of the United States.[6]

The Underappreciated Joys of Everyday Life

Many aspects of Waisman's photographs feel relatable and approachable. The viewer is brought into another space that ultimately feels familiar. Certain elements such as laundry drying on a clothing line or a set of bikes, including one outfitted with training wheels and parked outside of a trailer, reinforce the ubiquitous nature of American life. Waisman asserts that beauty exists in everyday life, in the spaces in between, that so often people chose not to photograph.

Several photographs in Waisman's *For I Shall Already Have Forgotten You* demonstrate the care residents of the trailer parks exhibit toward their homes. From a distinctive color added to a facade or an abundant garden including cacti, many attempt to make their house a home through decoration. These additive elements reflect the life choices as well as the taste and corresponding proclivities of the residents. While they might seem mundane choices, they also evoke the sublime joys of everyday life.

One of Waisman's photographs expresses the faith of the homeowner as a cross with lights hangs on the exterior of the home. The artist's choice to photograph this decorative element during the day as opposed to night makes the image even more compelling, as spirituality is suggested but not fully enacted. Regardless of the faith of the owner of this cross or the viewer of this photograph, the use of white lights associated with decorating to enhance this Christian symbol appeals to popular and collective memories.

Many photographers have sought to portray specific communities through extensive study and documentation. While Waisman identifies with photographers such as Richard Avedon, Sebastião Salgado, and Stephen Shore, others come to mind as well, including Alec Soth. The author of numerous photographic series produced at home and abroad, Soth's lesser-known body of work made in Colombia in 2002 while waiting to adopt a baby daughter, *Dog Days, Bogotá*, demonstrates a similar approach to Waisman's series highlighted in this volume. Soth's series portrays the city and its people but also explores themes of loneliness and abandonment.[7] He employs sensitivity portraying young people, unexpected landscapes, stray dogs, and the faithful on Cerro de Monserrate. Similarly, Waisman seeks a rich and varied depiction of a distinctive place and time.

Abstract Sensibilities

Waisman's photographs continuously demonstrate an attention to form, and specifically geometry. The shape of the trailers themselves become a strong protagonist in the work; in select photographs they fill composition with cube-like forms. Certain trailers have strong vertical or horizontal lines while other possess rounded edges. While many trailers are painted predominately white with accents, others present bright pink or lime green. The colors reinforce the shapes of the trailers themselves.

Contrasting the shape of the trailers, a photograph of a cracked floor breaks up their consistent form, providing an overall organic composition. The square linoleum tiles contain a repeated pattern of smaller squares, but its cracked surface offers a visual dynamism that disrupts the ordered forms. This linoleum tile that remains from a previous structure now subsists in nature. Worn by weather, time, and physical abandonment, the cracked floor possesses economic history, stories of the people who once lived at this physical location, and dominant abstract elements that inspire careful looking.

Certainly, contemporaries of Waisman play with geometry when rendering scenes of everyday life and documenting specific communities; however, moving farther back in time, a more compelling comparison emerges. Some of Manuel Álvarez Bravo's early works documenting street scenes in Mexico embody a sense of approachability while also emphasizing geometric form, including *The Daughter of the Dancers* (1933) or *The Crouched Ones* (1934). Although they are contemporary works, Waisman's photographs and their visceral observations belong to a long trajectory within photographic history.

Conclusion

Miami is a special place. For many, it exists in their imagination as a magical space with lush palm trees, sandy beaches, and a rowdy night life. While these common associations bear truths, Miami is also a city of endless quirks, urban sprawl, and an abundance of mangroves and mangoes. The city's economic inequity takes center stage, as many people navigate soaring rents and work multiple jobs while others see the warm weather and the luxury stores, restaurants, and cars coalescing into an adult playground.

The large immigrant populations enhance Miami and contribute to the diversity of this vibrant and varied place. An estimated 57 percent of Miami-Dade County residents were born outside of Miami.[8] Approximately 77 percent of Miami residents speak a language besides English at home.[9] There are longtime residents as well. Miami bubbles with influences from the Caribbean and the Southeastern United States. The Indigenous past and present of Miami remains underrecognized though it is a vital and inherent part of its history as well as its future.

Indeed, the city's history continues to unfold and take shape. Many histories remain undocumented and necessitate further research. On a recent evening in March, Miami residents gathered in large numbers to view the exhibition *Give Them Their Flowers: An Exhibit of Black LGBTQ+ Miami History* at the Little Haiti Cultural Center, curated by Nadege Green. This exhibition brought much needed attention to underrecognized narratives. Attendees rejoiced in the opportunity to celebrate, honor, and learn about people and places so often absent from established narratives about this complicated city.

Waisman also seeks to expand the visual representation of Miami. His visual elegy to the city's trailer parks, once advertised as a haven for older adults seeking a peaceful and warm environment for their later years, reveals the challenges

and realities of life in these vulnerable spaces. The study of the human condition informs the artist's work. He recalls, "You see, I wanted to be a philosopher growing up. I dabbled into sociology for a while much later and found refuge in the arts."[10] Waisman embraces interdisciplinary thinking, citing influences such as Michel Foucault, Erving Goffman, Karl Marx, and Max Weber while also looking to literature for kindred spirits.

The title, *For I Shall Already Have Forgotten You*, comes from a poem by the Chilean writer Pablo Neruda. Language shapes the artist's approach to image making. In researching this project, Waisman finds the combination of text and image in the advertisements and occasional documentation of text within an image particularly appealing. Yet, ultimately Waisman sees the camera as a type of writing device in which he crafts visual narratives and strives for new translations.

Notes

1 Conversation with the artist, March 18, 2023.
2 Andres Viglucci, "Miami-Dade's Economic Inequality Is Nation's Second-Worst," *Miami Herald*, April 24, 2019.
3 Alexandra Martinez, "Luxury Housing Is Threatening to Wipe Out Miami's Trailer Parks," *Vice*, May 16, 2019.
4 Conversation with the artist, March 18, 2023.
5 Conversation with the artist.
6 Bill Owens, Geir Jordahl, Kate Jordahl, Kim Komenich, and Shelley Rice, *Bill Owens: The Legacy of Suburbia, Photographs 1964–2020* (Bellingham, WA: True North Editions, 2020).
7 Alec Soth, *Dog Days, Bogotá* (Göttingen, Germany: Steidl, 2007).
8 Tim Craig and María Luisa Paúl, "Florida Has Long Been a Sanctuary for Immigrants. That's Now Being Tested," *Washington Post*, September 24, 2022.
9 Brittany Shammas, "Miami Is Only U.S. City Where Most Language Learners Are Studying English," *Miami New Times*, October 13, 2017.
10 Conversation with the artist, March 18, 2023.

PHOTOGRAPHS

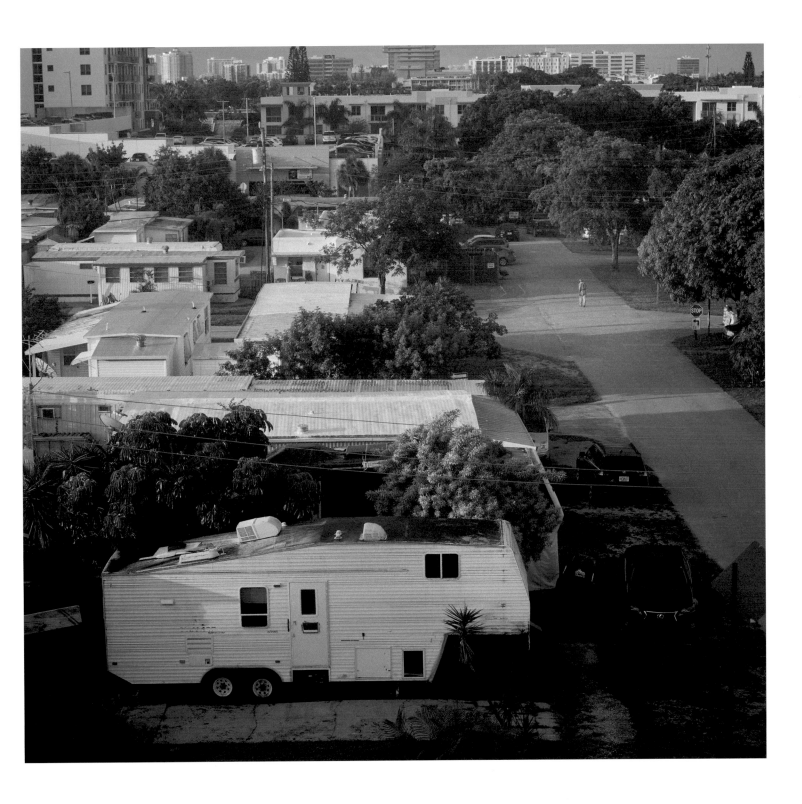

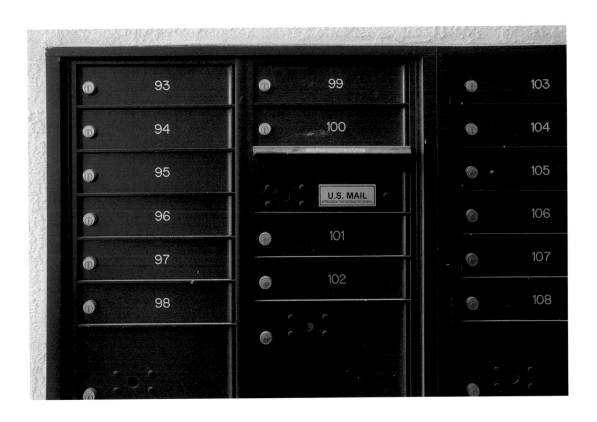

for I shall already have forgotten you

for I shall already have **forgotten** you

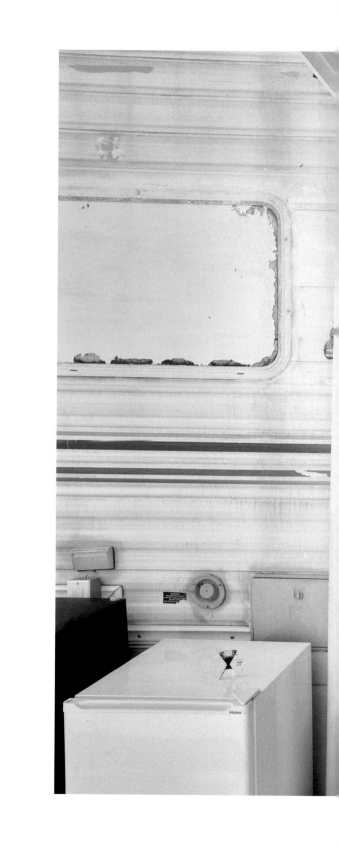

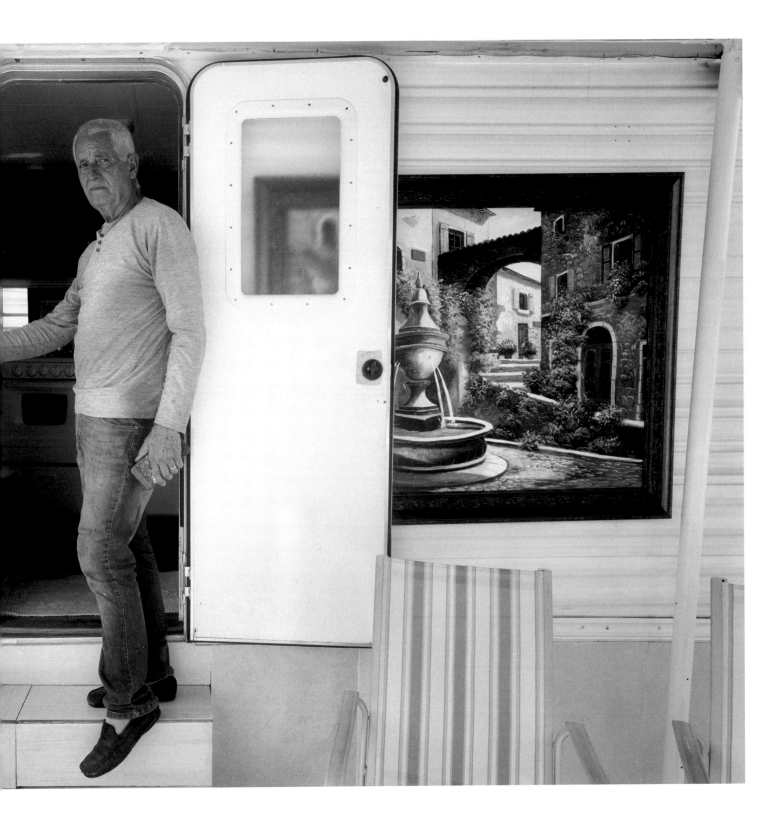

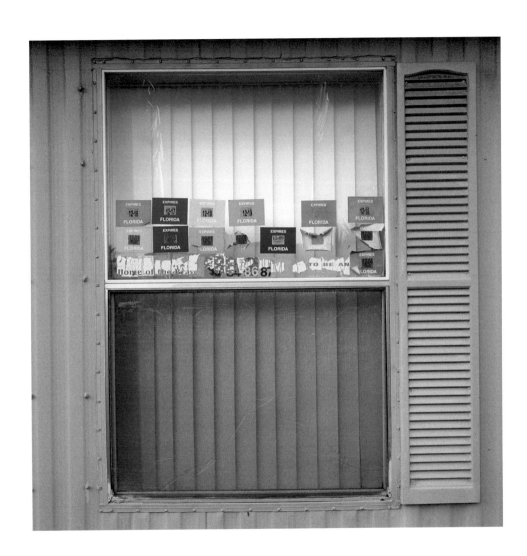

She Likes the Life

Most Trailer Parks Crowded, Unkempt

Editor The Herald: I have just read the letter of Walter Edenfield in regard to zoning for trailers. I agree wholeheartedly with him, especially about electricity costs and attitudes toward trailerites.

I sold my home several years ago and bought a 42 foot trailer, two bedrooms, bath, kitchen and living room, to cut living expenses. I had to work and the upkeep of home, plus child care and daily expenses, took every penny I could earn.

I like trailer life very much but I have found that most trailer parks are overcrowded, unkempt and overloaded by boss managers who show favoritism in enforcing park rules (no play areas for children).

It's difficult to keep young children restricted to a 35 by 50 foot lot, on which is parked a 42 foot trailer with a large patio.

Many, like myself, have put time and money into landscaping their lots and can't afford to be moving out.

I do not have a car and the expense of moving is more than I can afford, plus the fact that most of the parks are the same.

I pay 7 cents a kilowatt for the first 100 kilowatts, then 3 cents for each additional kilowatt—average, $10-for two persons per month, plus $25 rent per month after first six months' rent, plus $1 city water per month.

I have electric hot water heater and refrigerator, no television set or fans.

I have a gas stove. Gas costs about $2.25 a month.

We are not allowed to use our own washing machines, but must use those rented by the park owners at 25 cents for 28 minutes' load, automatic, or 10 cents for 30 minutes load, wringer type. My laundry bill averages weekly about $1.50.

Why not a law to control resale of power at a set rate, also to regulate lot rentals and water?

I pay $12 a year for city water for two persons and some of my neighbors with five or six in the family pay the same amount. Is that fair?

TRAILERITE

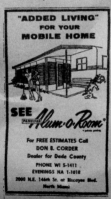
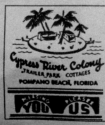

Mobile Home Owners No Longer Gypsies, But Community Asset

Editor The Herald: The recently published letter asking why neighborhoods are not zoned for mobile home locations is of timely interest to thousands of owners and prospective buyers of this type of residence.

More than three million people now enjoy this way of living in the United States, and Florida has a large share of the mobile home population, much of it on a permanent basis.

The National Association of Mobile Home Manufacturers is conducting national and local campaigns to improve attitude such as your correspondent cited.

As a result, numerous city and county governments have come to realize the stability and merits of these permanent and sometimes transient residents and have amended their restrictive ordinances.

Florida's West Coast already has made much progress with the establishment of several large areas specifically designed for mobile home living.

No longer is the mobile home owner considered a gypsy because of wanderings across the nation's highways. Once called a "trailer," the mobile home now usually is found permanently located for at least an average of 36 months.

Nor is the once-disreputable "trailer court" of years ago even thought of in the category of the modern, well-constructed, competently-operated mobile home areas of today.

There is the same contrast between the two as between the old shack-like overnight "tourist cabin" and today's present super-deluxe motels.

This is a half-billion dollar industry and one vital to the individual and family confronted by ever-rising costs of land, houses, furnishings and equipment.

If city and county fathers, particularly in such places as Florida, California, Arizona and similar sunshine and retirement areas, do not make provisions for the migration of mobile home owners, they will be losing not only stable and desirable population, but the continuous additional revenue from taxes and the local sales of food and commodities.

People go where they are most welcomed, community-wise, and usually locate there permanently.

PROSPECTIVE OWNER

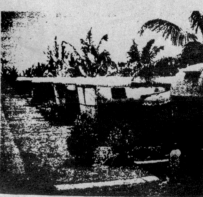

NOT ALL TRAILER PARKS ARE NEAT AS THIS

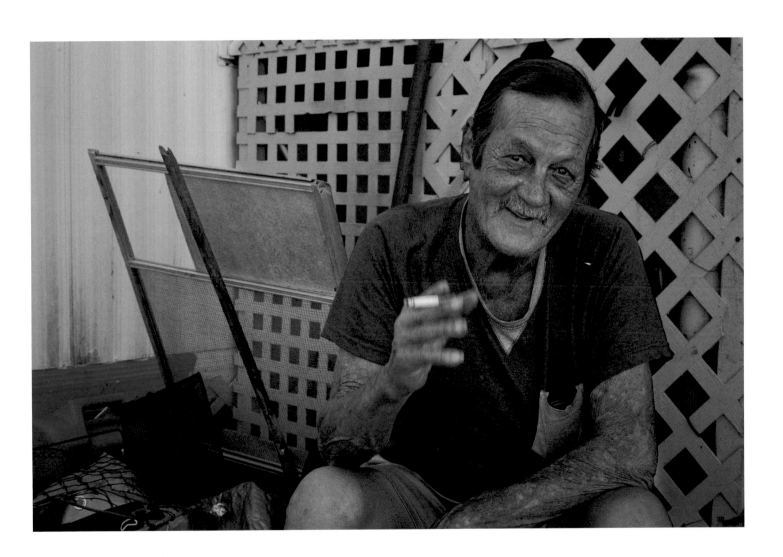

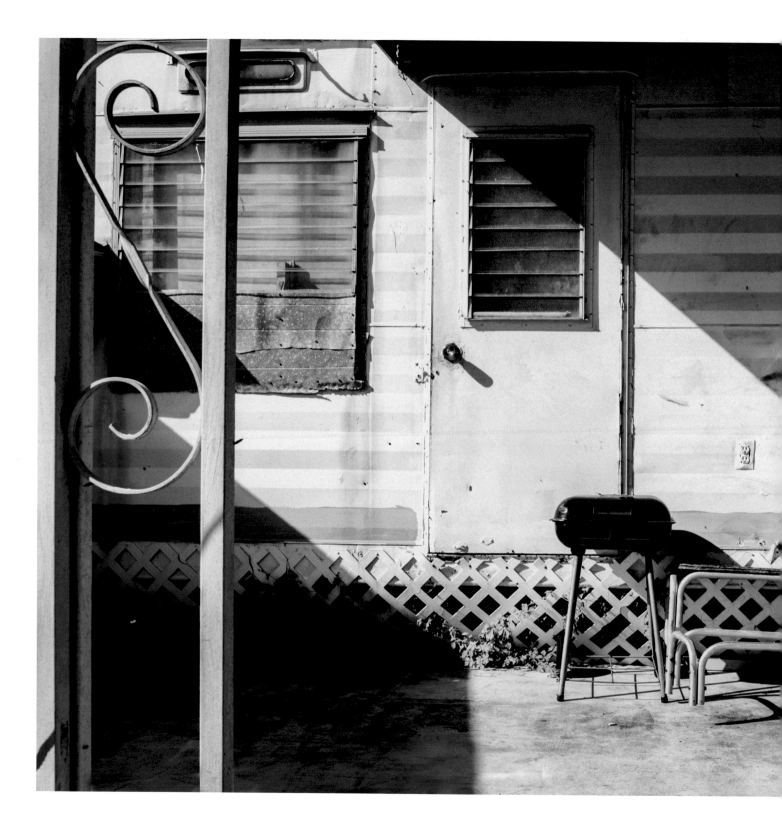

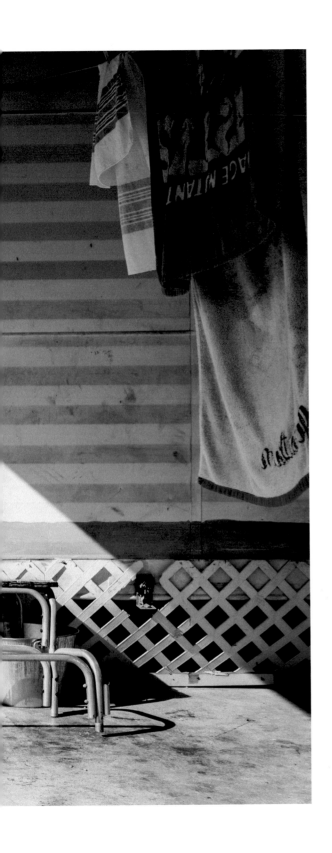

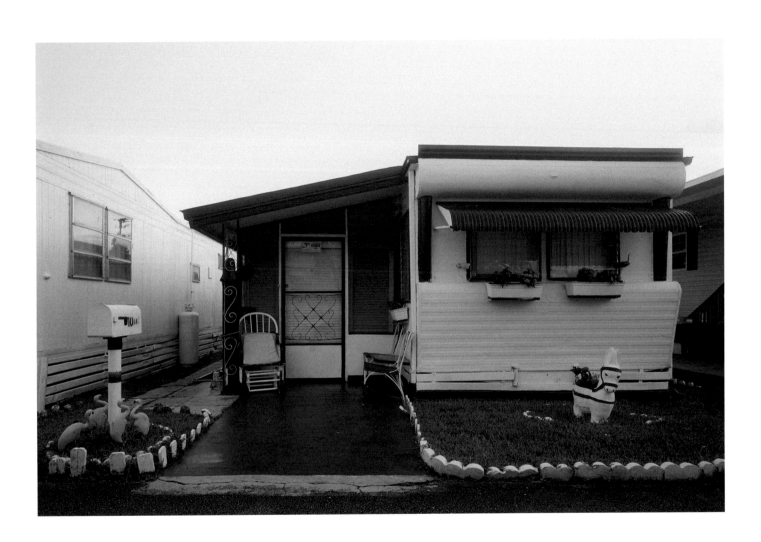

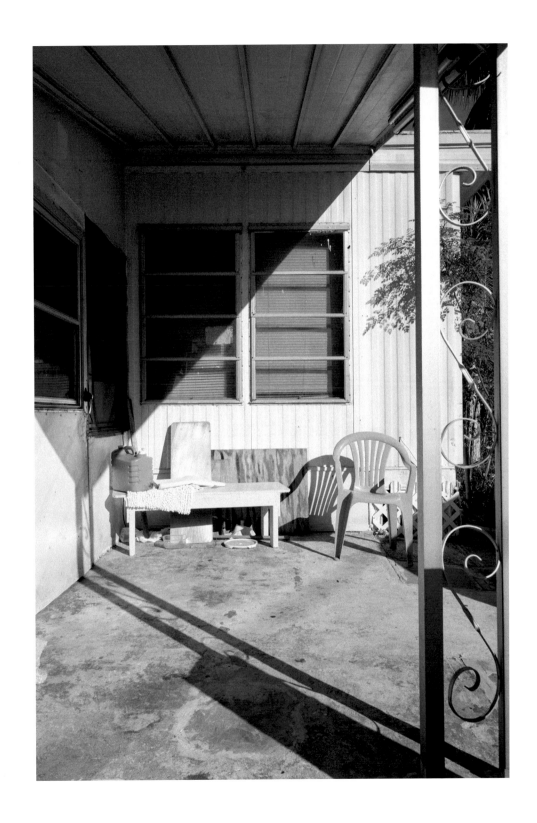

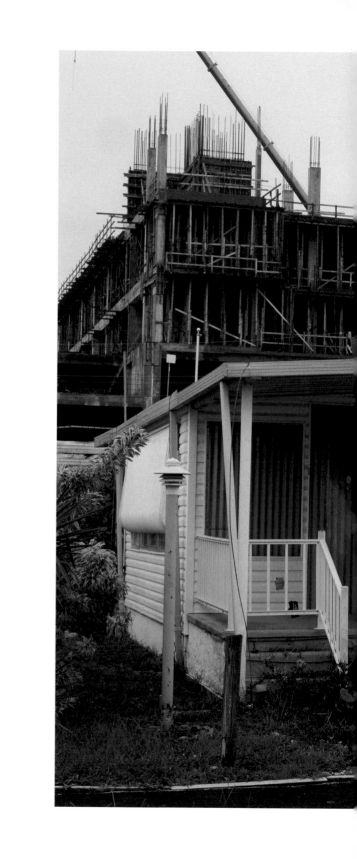

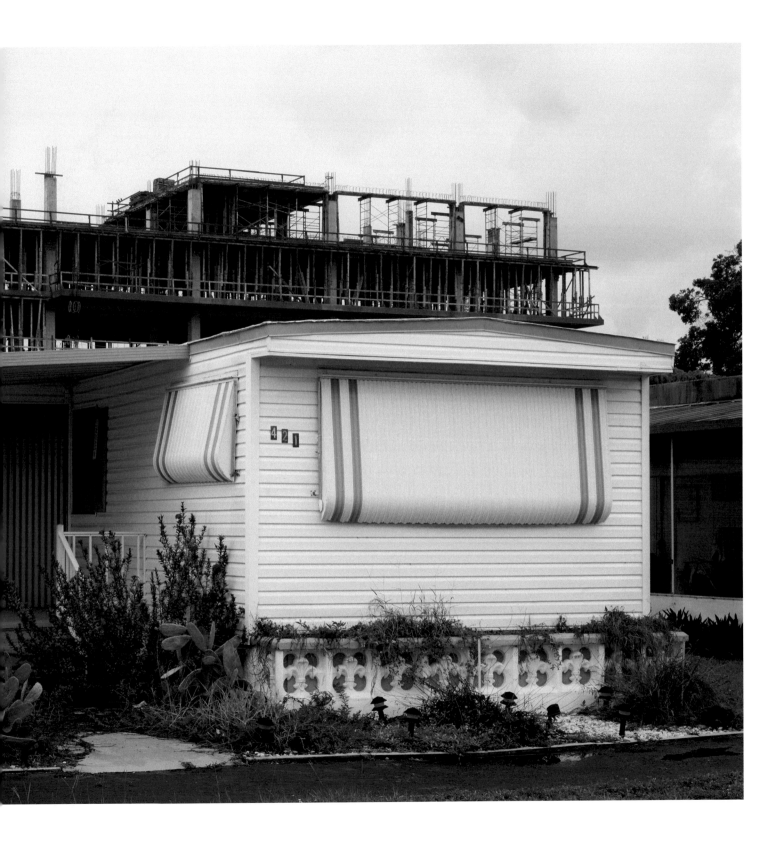

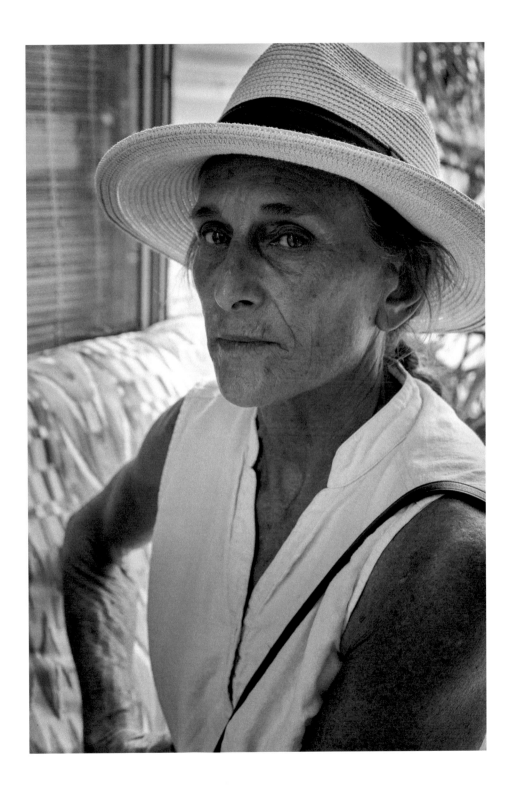

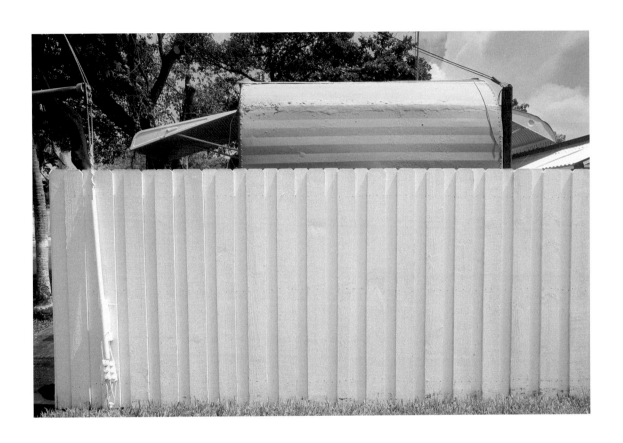

Think You Can't Afford a Home? So Did They

by Earni Young

Joe and Judy Morris had never considered buying a mobile home before moving to Miami from Key West a year ago. They didn't even decide to buy a home until after two months of fruitless searching for an apartment that would accept their daughter and the family dog.

"We must have looked at 20 houses before we finally found a used home," said Mrs. Morris. The house, built in 1972, cost $54,000 and had 1,500 square feet. It needed a new roof and the kitchen and bedroom needed remodeling".

The couple was almost ready to sign a contract on the conventional house when they found their current manufactured home.

ALTHOUGH TECHNICALLY a mobile home, the 1,600-square-foot home is a far cry from the flat-topped tin cans once towed down America's highways. It has wall-to-wall carpeting, central heating and air conditioning, a wet bar, three bedrooms, two baths and a modern kitchen with two ovens. Everything is new.

"We stopped calling it a mobile home after the first walk-through," Mrs. Morris said, "It's great".

The planned subdivision and others like it around the country are being touted by federal housing officials and the mobile home industry as the answer to the housing shortage faced by low- and moderate-income families that can no longer afford the prices asked for conventional homes.

These subdivisions are replacing the often shabby trailer parks that have contributed much to the poor image of mobile homes.

Asbestos Causing Family Relocations

The Governor has declared an emergency on Wednesday, freeing $100,000 in taxpayer money to relocate families from mobile home subdivisions contaminated with cancer-causing asbestos.

Some of the funds will be used by the state Division of Emergency Services to provide about 30 temporary mobile homes to residents according to a Governor's aide. The subdivision nestles against the abandoned Mulrich Asbestos Corp. mill. Federal and State health officials have said the 120 residents face a much greater than normal danger of contracting cancer and other lung ailments because of their exposure to the asbestos.

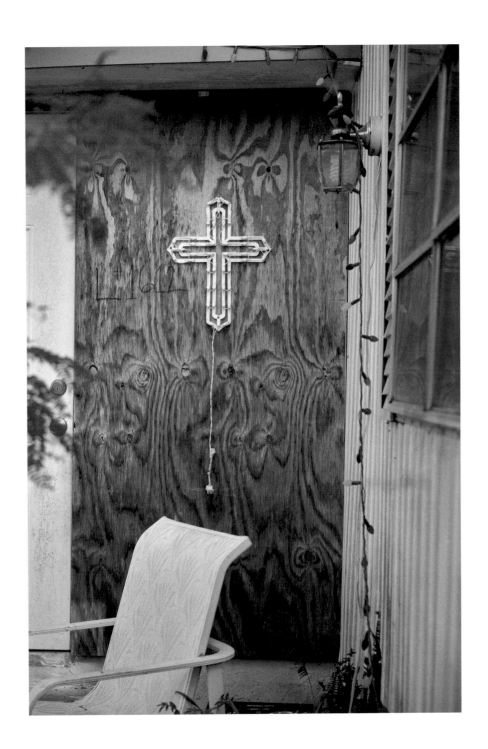

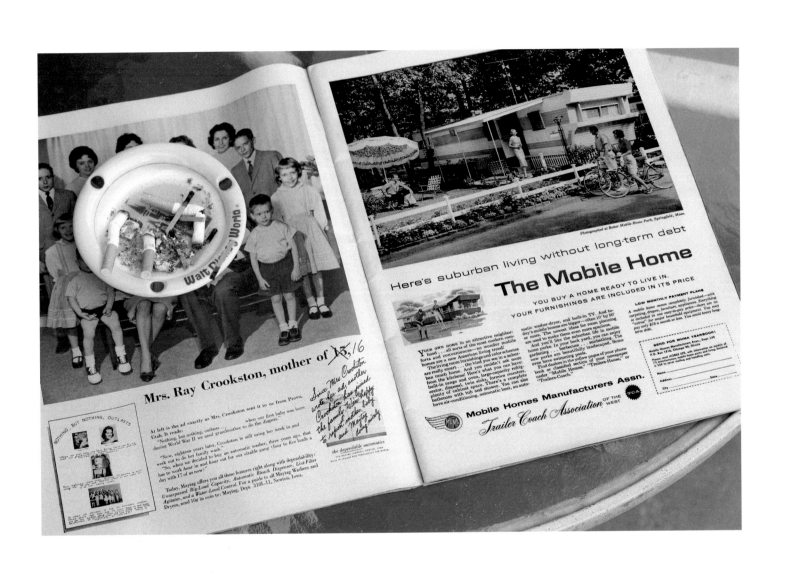

What is
Your Home Worth ?

If you study the homes offered herein, with fresh listings and pictures every month, you'll have a good idea of what your present home is worth.

And if it is too large, too small or not in the right location to provide you with the things you want most from home ownership - this would give you some ideas.

Its size is ideal for savings - to shop from the comfort of your home, comparing features, locations and prices.

It doesn't cost anything to "window shop" and it could lead to future economies.

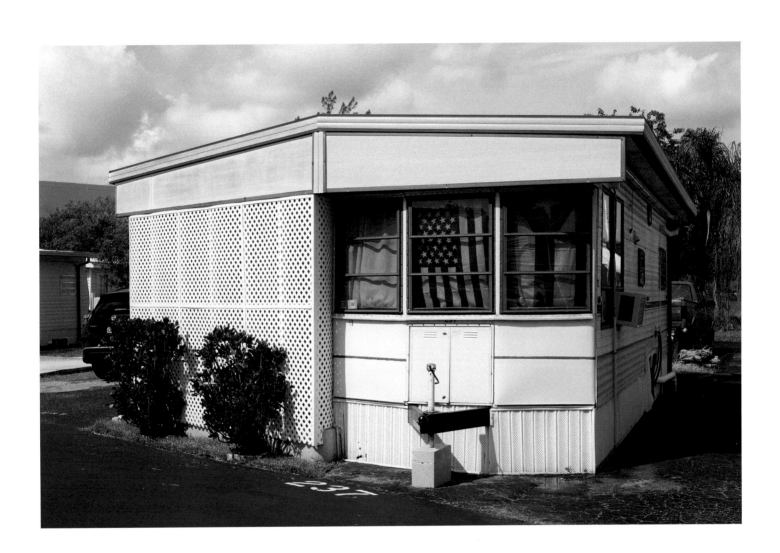

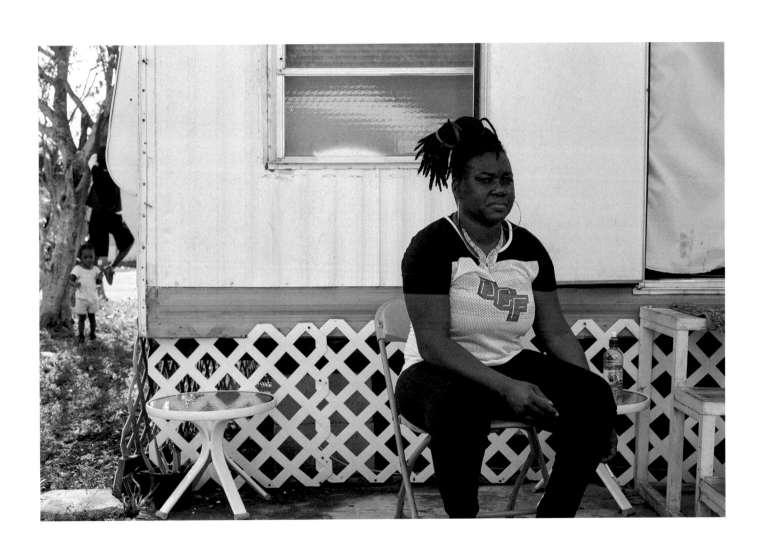

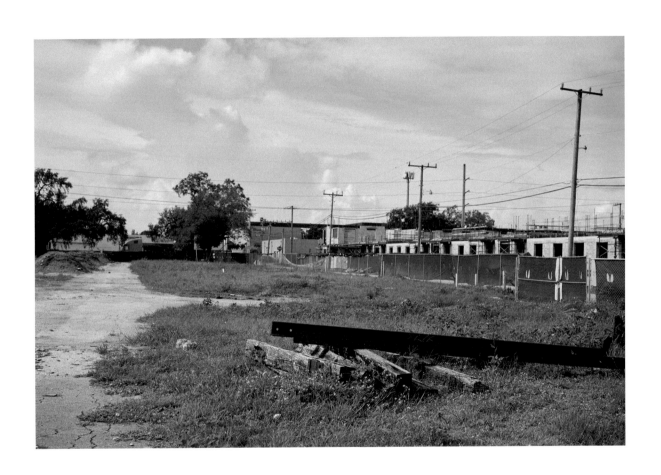

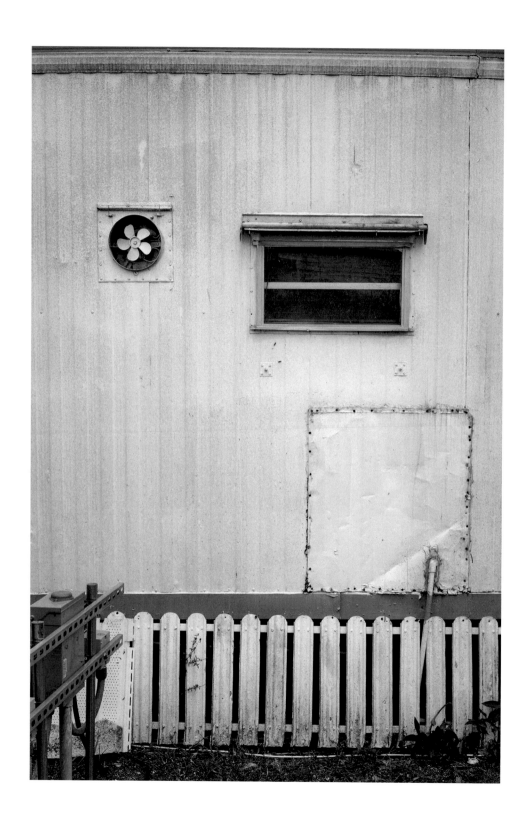

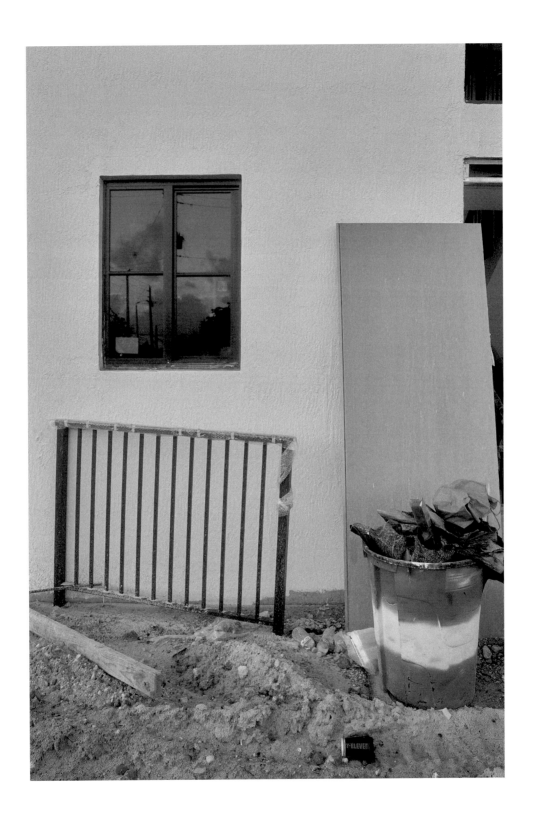

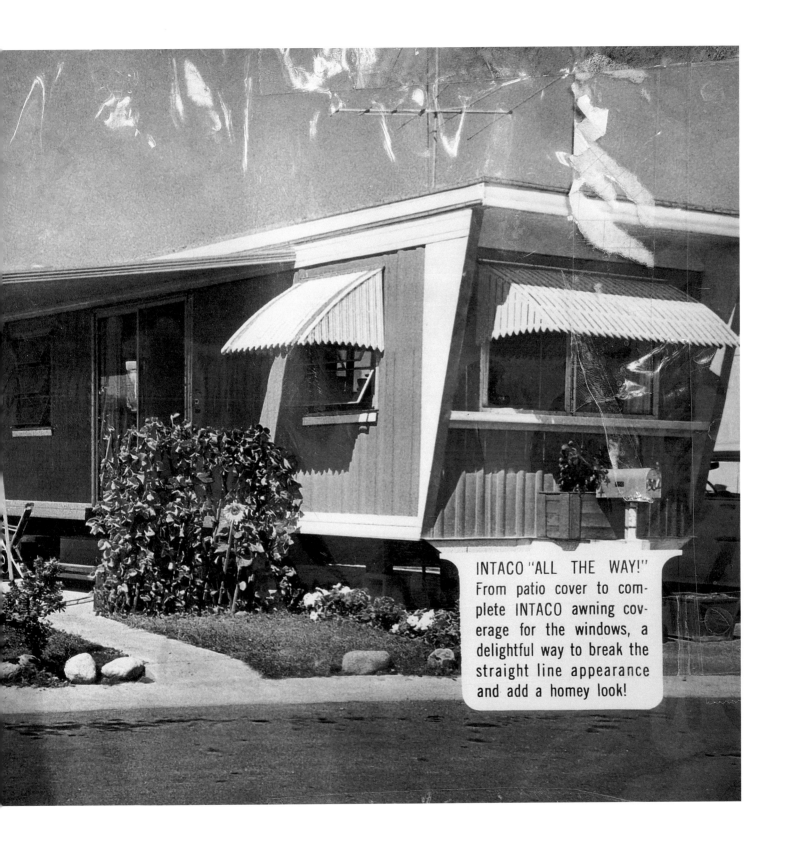

INTACO "ALL THE WAY!"
From patio cover to complete INTACO awning coverage for the windows, a delightful way to break the straight line appearance and add a homey look!

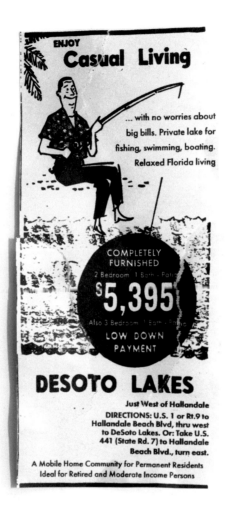

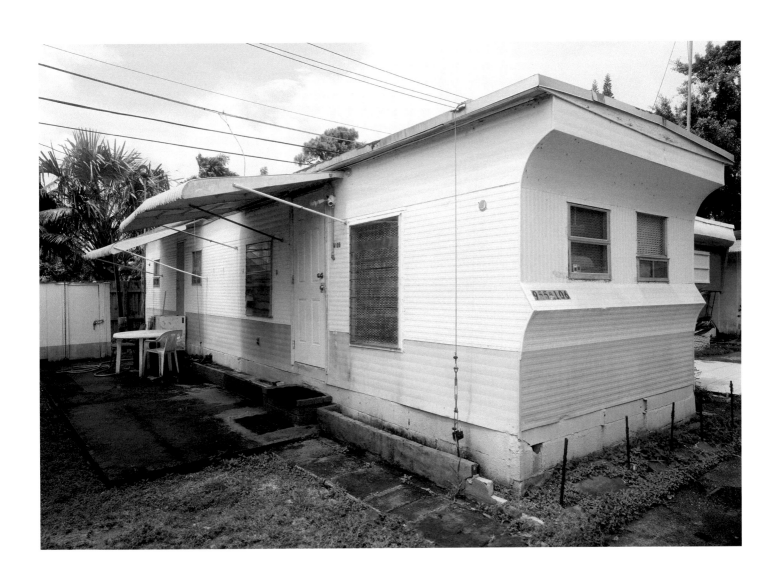

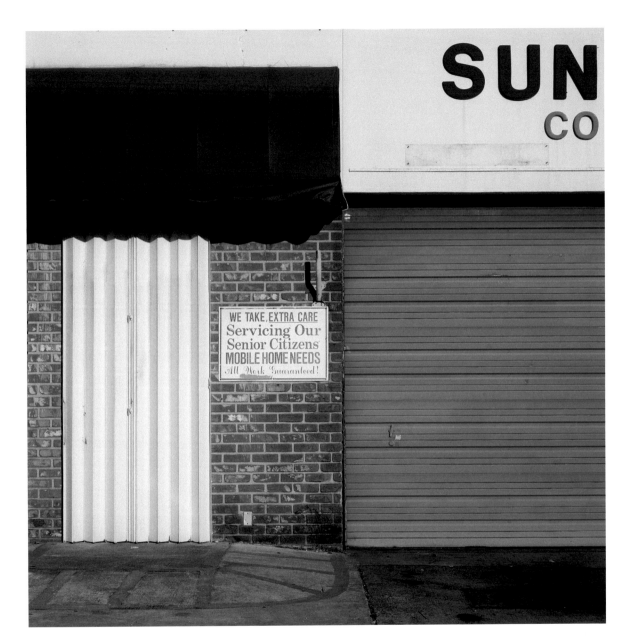

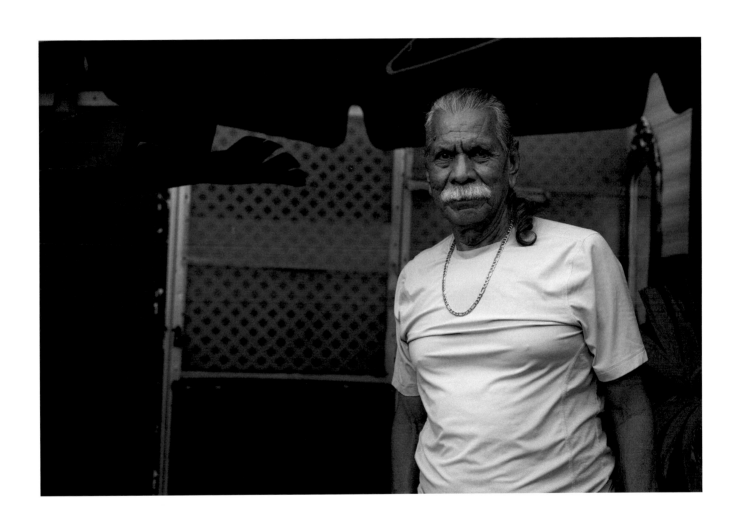

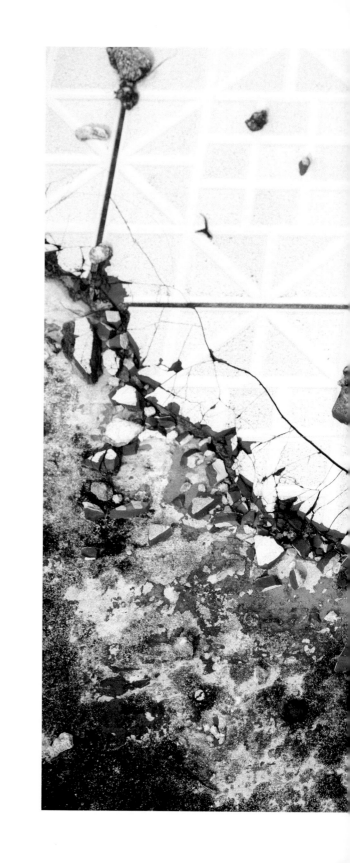

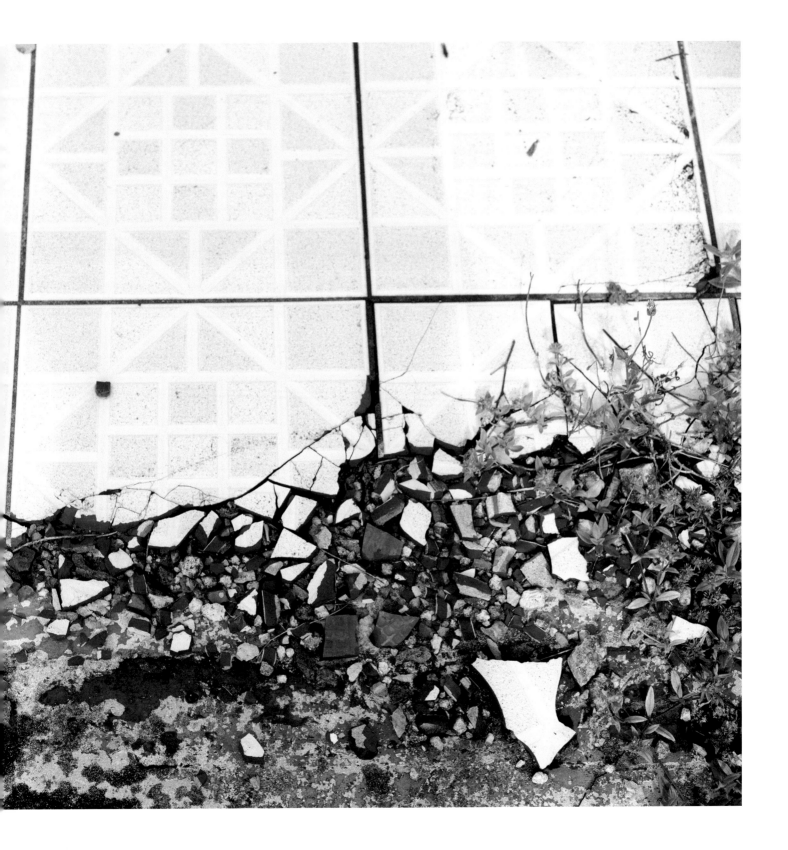

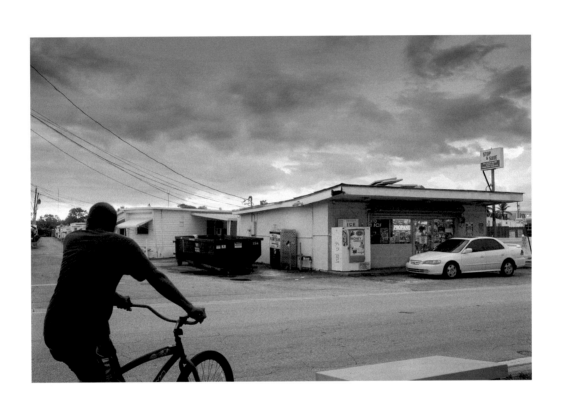

Your Own Home

When and Where You Want It

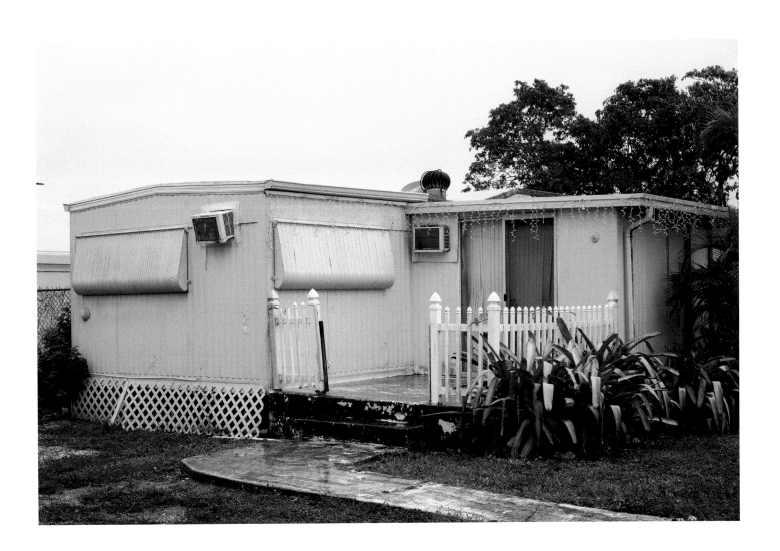

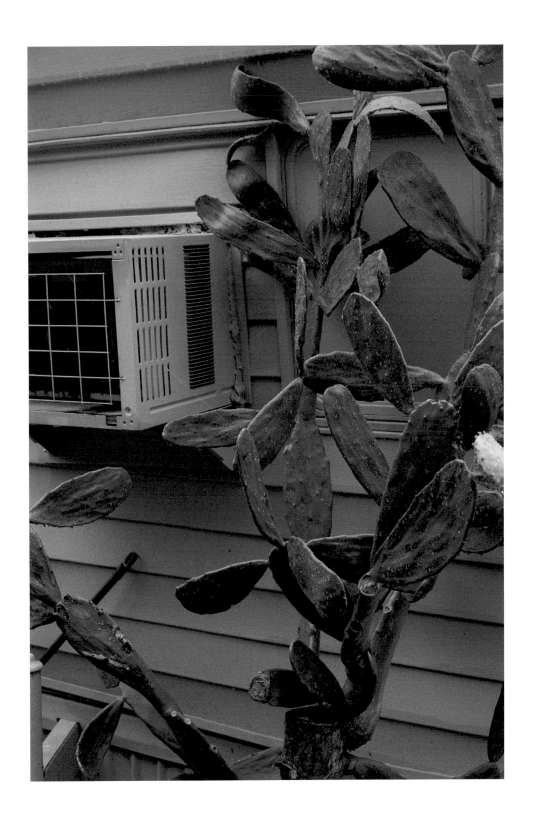

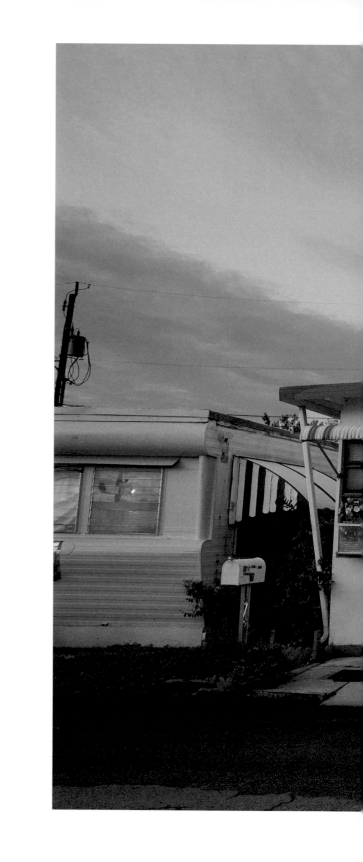

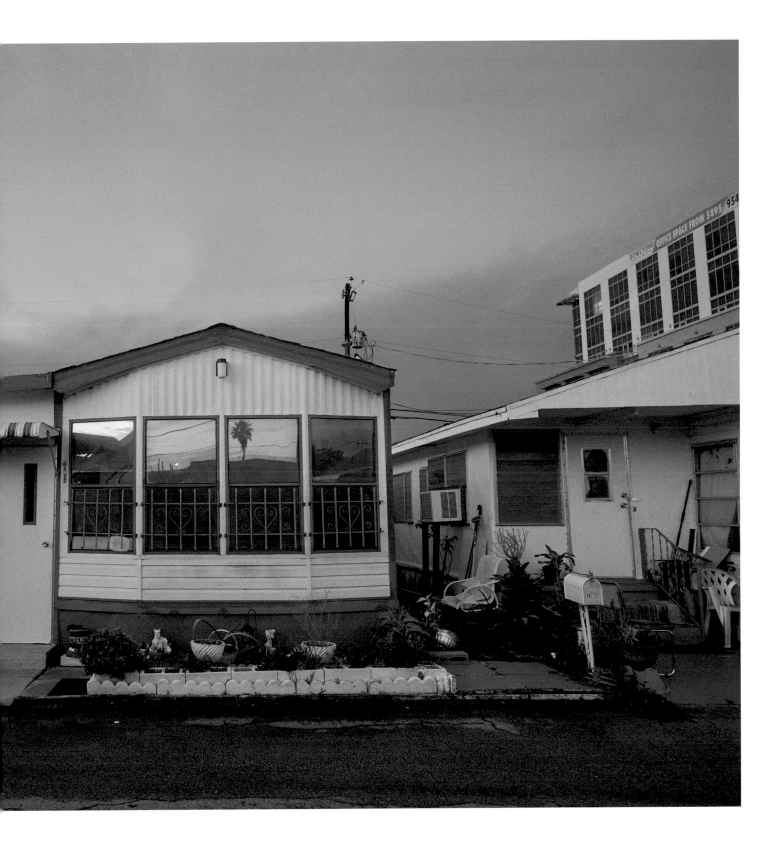

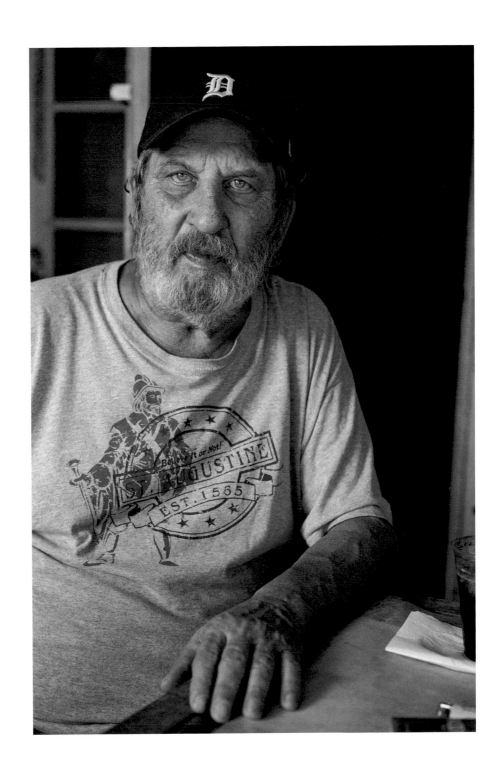

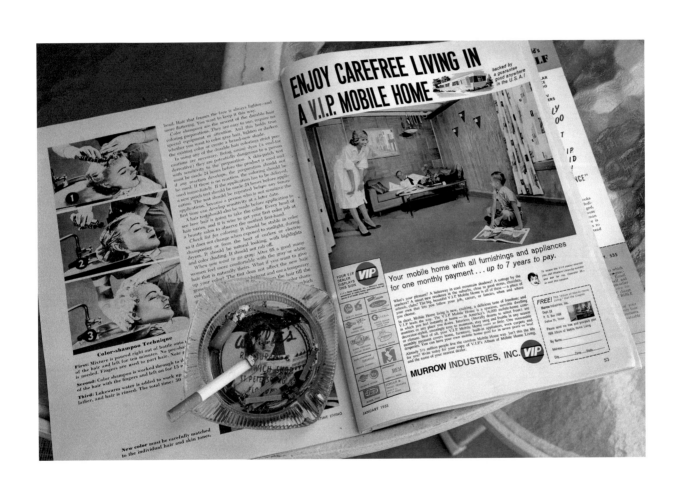

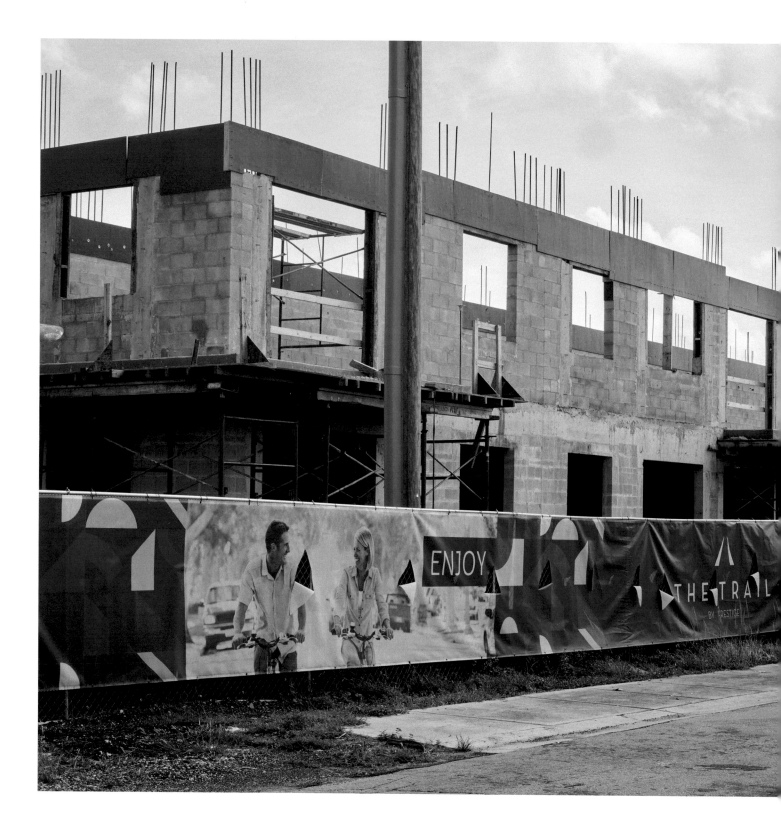

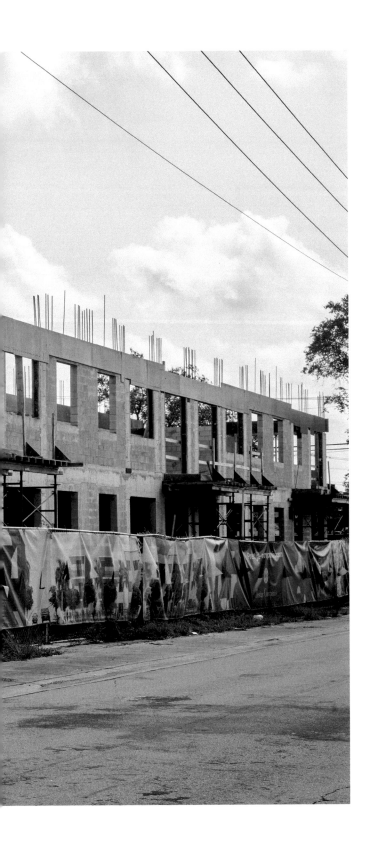

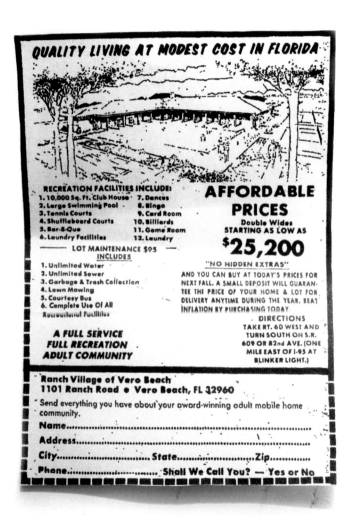

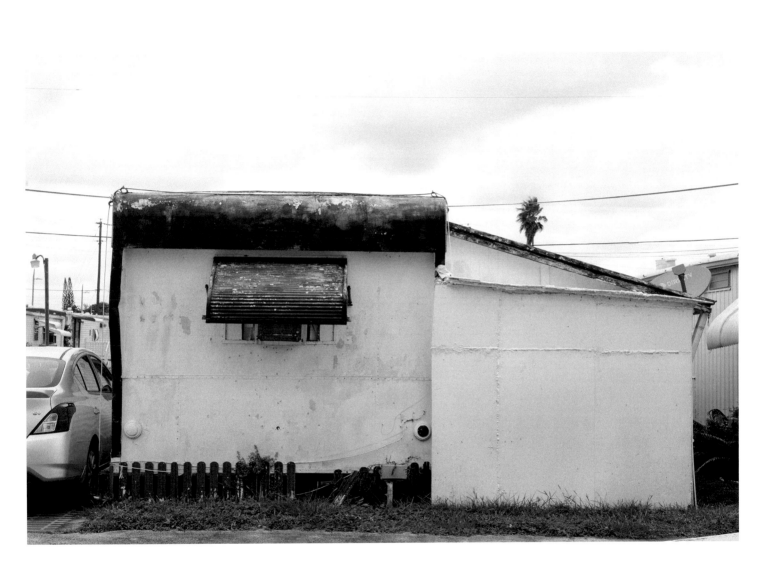

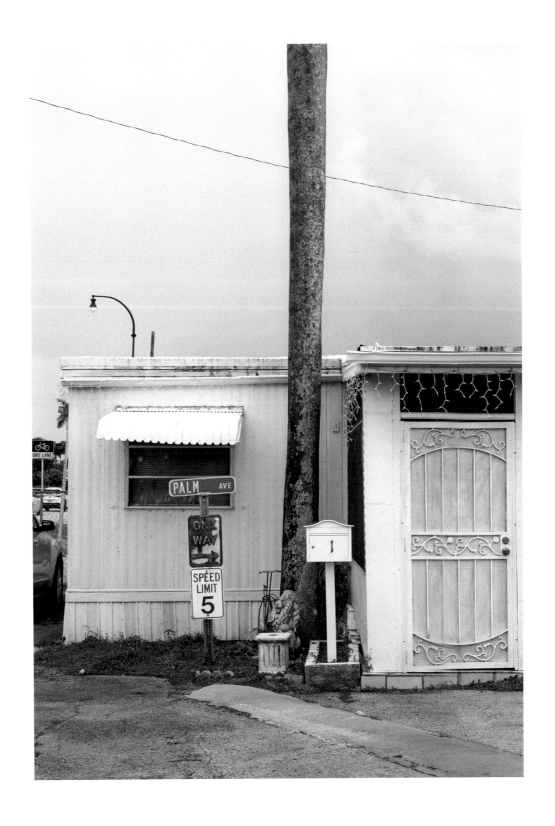

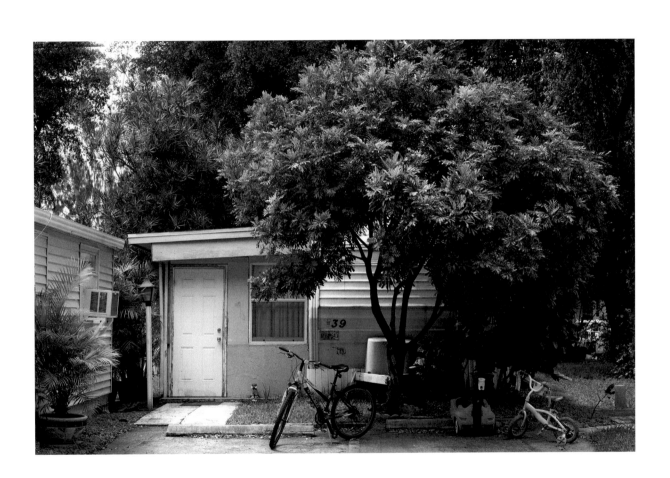

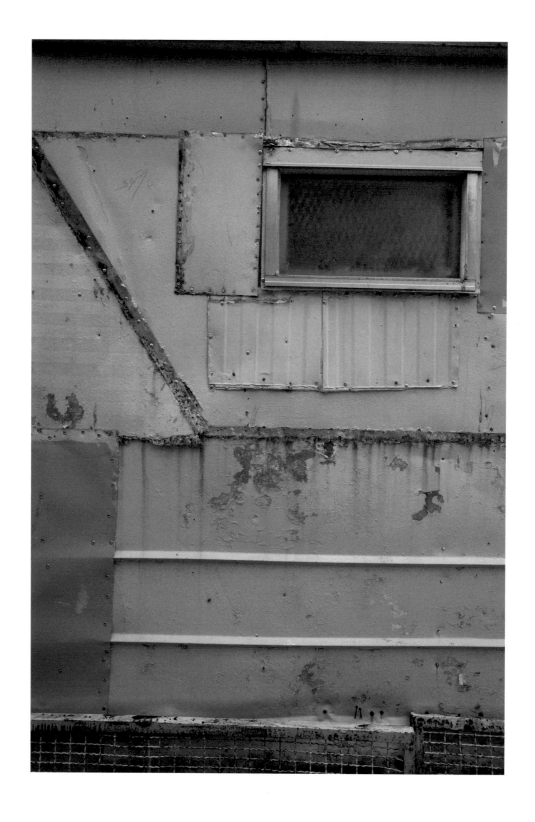

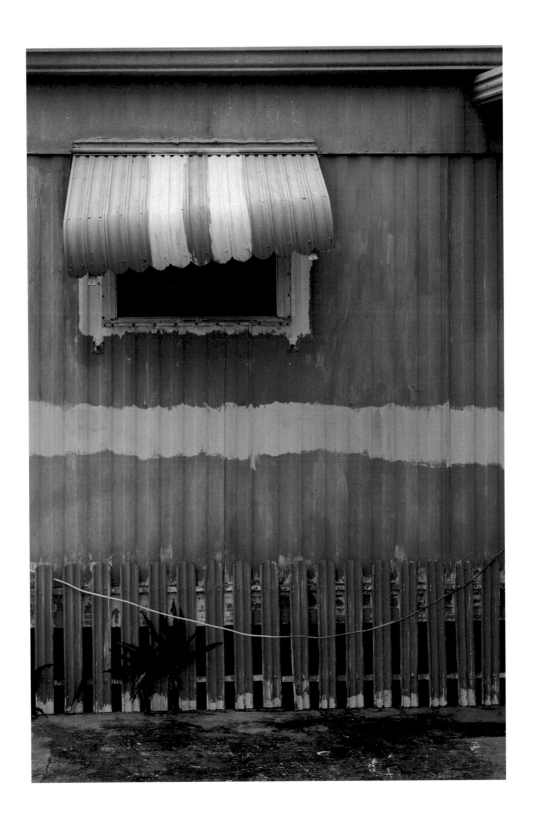

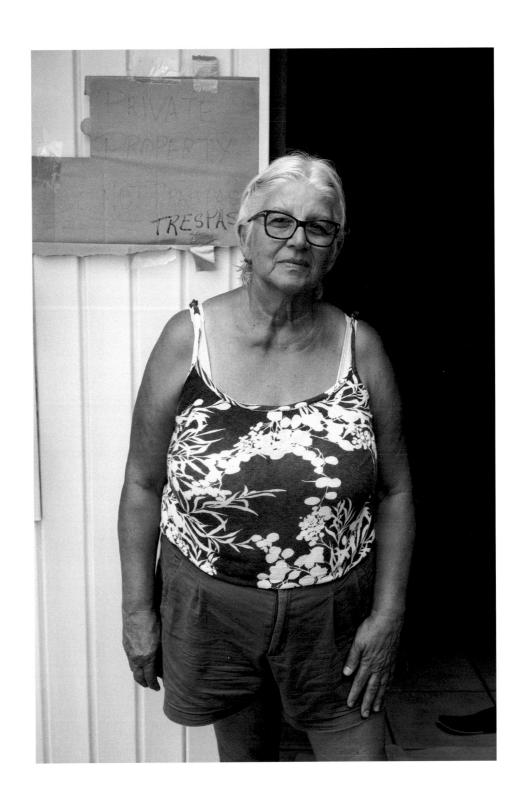

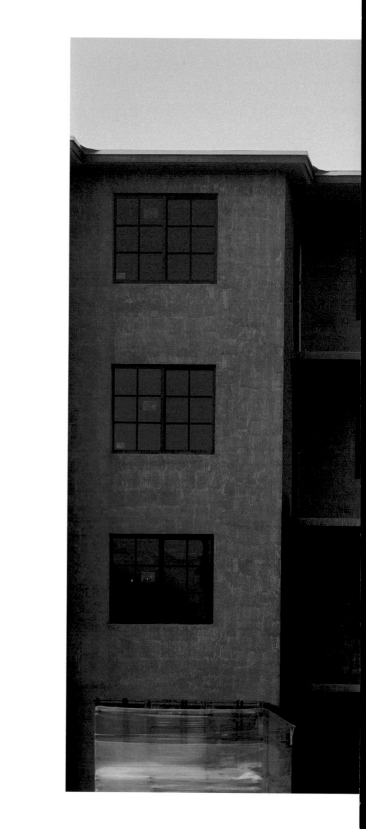

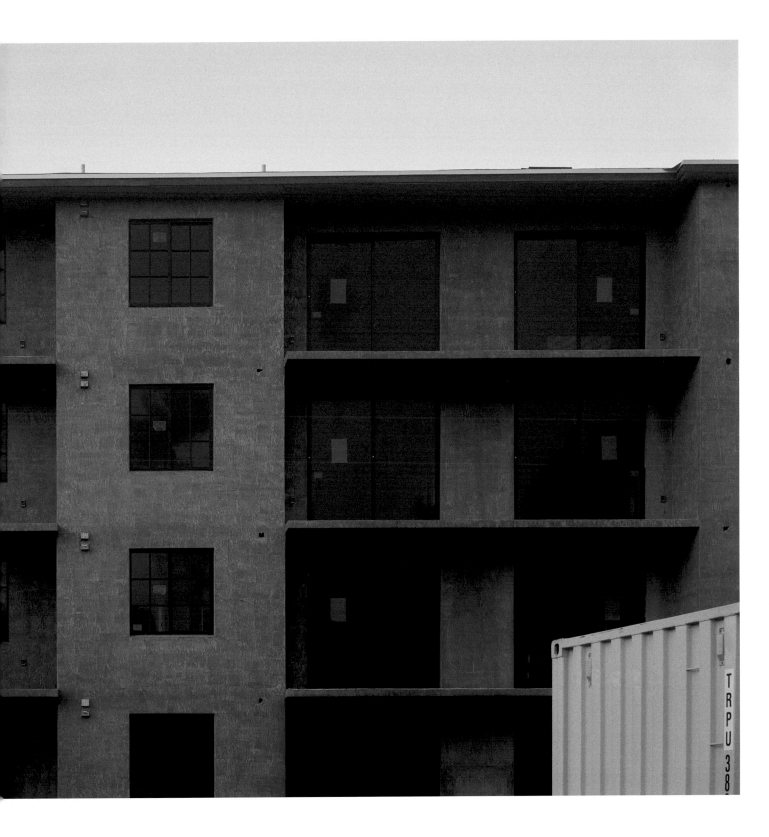

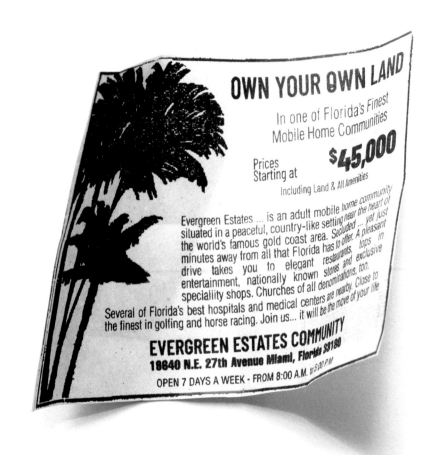

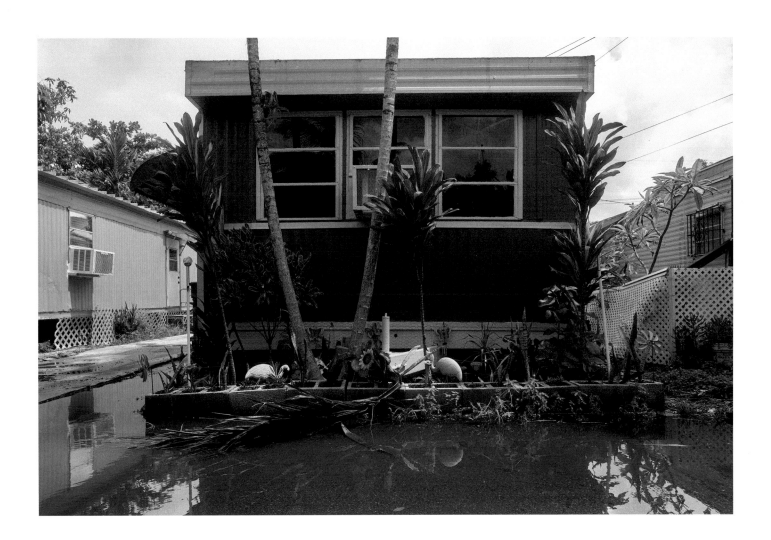

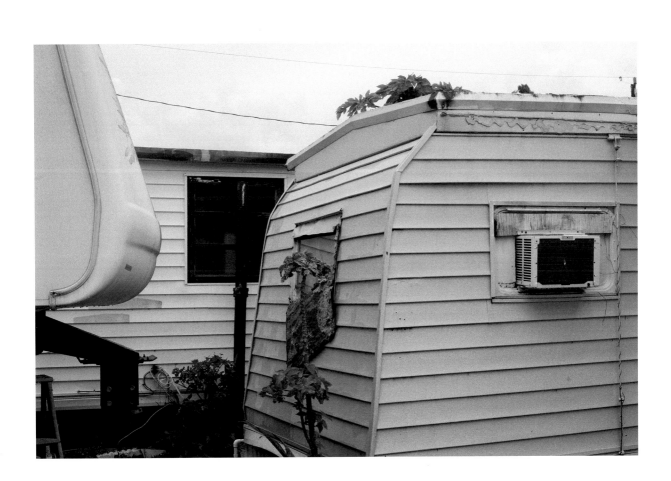

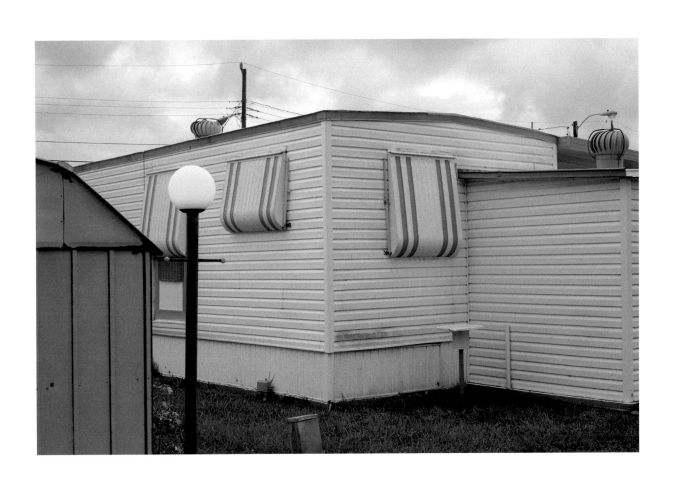

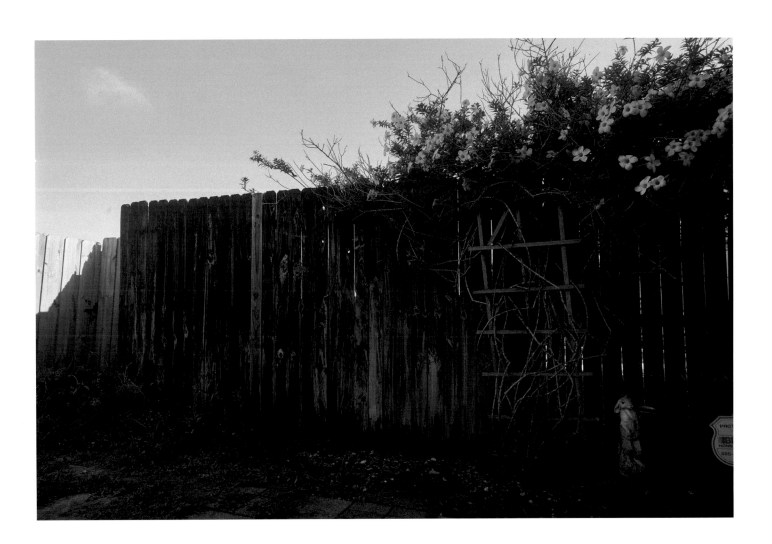

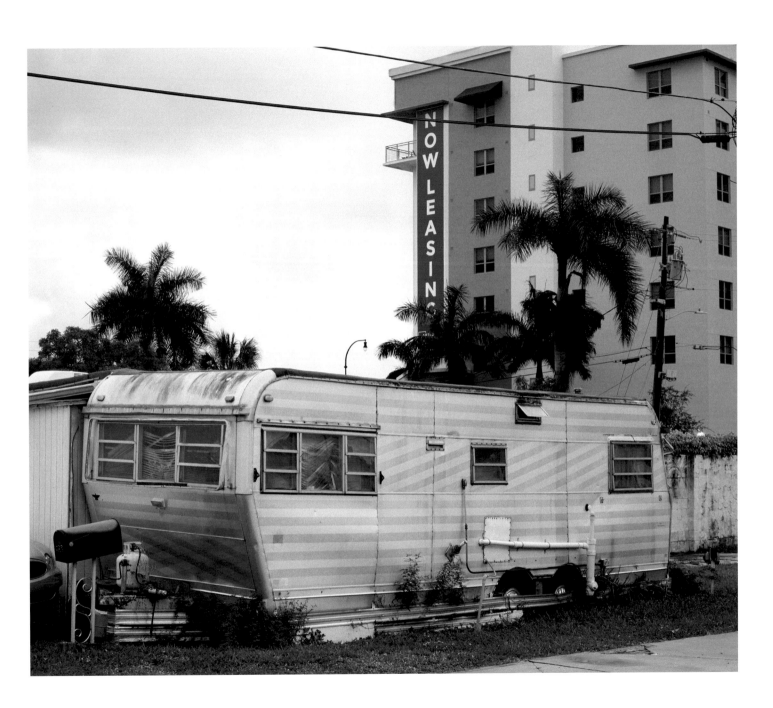

"If You Forget Me"

I want you to know	Quiero que sepas
one thing.	una cosa.
You know how this is:	Tú sabes cómo es esto:
if I look	si miro
at the crystal moon, at the red branch	la luna de cristal, la rama roja
of the slow autumn at my window,	del lento otoño en mi ventana,
if I touch	si toco
near the fire	junto al fuego
the impalpable ash	la impalpable ceniza
or the wrinkled body of the log,	o el arrugado cuerpo de la leña,
everything carries me to you,	todo me lleva a ti,
as if everything that exists,	como si todo lo que existe,
aromas, lights, metals,	aromas, luz, metales,
were little boats that sail	fueran pequeños barcos que navegan
toward those isles of yours that wait for me.	hacia las islas tuyas que me aguardan.
Well, now,	Ahora bien,
if little by little you stop loving me	si poco a poco dejas de quererme
I shall stop loving you little by little.	dejaré de quererte poco a poco.
If suddenly	Si de pronto
you forget me	me olvidas
do not look for me,	no me busques,
for I shall already have forgotten you.	que ya te habré olvidado.

Pablo Neruda

"Lots" of Uncertainty

A Journey into a Disappearing World in Florida

Louis Herns Marcelin

I.

For I Shall Already Have Forgotten You offers us a space to think about how we inhabit the world. As an immigrant himself, Diego Waisman delves into the challenges of movement, displacement, and circulation through the lenses of "the house," more specifically the mobile home. He juxtaposes iconographic images of mobile homes as ephemeral realities crushed by real estate markets, gentrification, and cold calculation. The displacement of mobile homes, and those who live in them, reveal the nature of a city governed by predatory capitalism.

The photos depict the house/mobile home as a way to think about the idea of the city, drawing from a range of neighborhoods in South Florida. Taking the house as simultaneously a built structure, a constellation of relationships, and a pawn of larger political and economic systems, the photos move across scales to question how people's lives and worlds are made and remade in relation to the house and housing configurations.

Piecing a historical perspective into the work, he has created another layer of understanding, whose themes might not be otherwise evident. *For I Shall Already Have Forgotten You* helps us feel and be moved by the history of housing development and ownership in Florida in general, and in Miami-Dade County in particular. It is a history captured in gendered and racialized clips of advertised dreams of paradise, ownership on pristine beaches, and pleasant weather that was consistently sold to the retirees and dreamers after the world wars. A world made of promises, the American dream, freedom, and democracy primarily for white Anglo-Saxon America, sidelining the oppressive plights of segregated Afro-descent and Indigenous populations of this country.[1] Over time, as the photographs show,

these promises have been flatly broken. Today we see that for the marginalized ethnic minorities, especially from Black, Indigenous, and Hispanic communities, jobless people on the move, veterans, and those facing catastrophic illnesses and debts, the broken promises have translated into nightmarish displacements; evictions or outright spatial erasures of socioracial histories and heritages; poverty and anxiety about the future. More than an essay, this book is an invitation to reflect on a journey of human experience, resilience, small successes, and defeats.

II.

The journey opens with the challenge of scales of reality: the house, the city, and the relationships between them. At the microscale, the house is depicted as a way to inhabit the city and locate yourself within it. At the same time, the house is a way of expressing sociocultural values and symbols of stability and social status. Similar to Roland Barthes's poetic analysis, Waisman captures images of the mobile house qua "home," a sociocultural symbol that reflects the ways in which owners' aspirations and desires are shaped by the socioracial and political economic contexts in which they live. He invites us to reflect on the dystopian world of the market that crushes some people's aspirations and desires—especially those of marginalized people—while overly rewarding the aspirations of others. The book questions our indifference to the disappearing worlds of the dispossessed, and, ultimately, the assumptions that shape our understanding of the ways we inhabit our cities and the world. By acknowledging and exploring the multiple meanings and interpretations attached to the mobile home/house, we can better understand how housing is situated within larger socioracial, economic, and political contexts.

III.

Behind each picture of a mobile home in this book, there lies the author's interdisciplinary process and research, shaping the way he engages the home. At the core of his methodology is field ethnography, landscape configuration, the history of the mobile home/house, and where the history fits into those communities. An ethnography that captures how the socioracial landscape and urban segregation and their historical legacies actively shape the real estate market in Florida and Miami-Dade County, as is the case in other urban settings of the United State.[2] He also brings to bear reflexive photographic techniques. Important background questions emerge

in that process: How have mobile home park communities emerged? How have they been integrated into the development of South Florida's municipalities? What does it mean to live in a mobile home/house? Who lives in these mobile homes? How do those who live in mobile homes feel about the cities in which they live? How are they connected to others in the community and to other communities and city services? These are essentially existential questions. And how and what to capture in the image? These questions call for new investigations, thinking about social theory, methodology, epistemology. They are framed along generational lines and different layers of time that are at play between and within different ethnic groups' idea of a home; different organization of socioracial/ethnic spaces, which, in turn, are sites of interethnic competitions and struggles;[3] complex family processes from a range of regions in the United States and other countries to their locations in Florida's urban spaces.[4]

This interdisciplinary methodology and research defined Waisman's interviews and the stories he gathered; sociality inside the home/house, uses of space and strategies of engagement with neighbors and neighboring quarters along with strategies of their confinement; home/house members' plans and ideas for their futures. Behind these photographs, Waisman built unique stories worthy of a thesis or dissertation—from families striving to rebuild after expulsion (as illustrated in Felipe's portraiture); truncated aspirations for the future (Marty's family); resilience and resistance (Alberto's family). From these interviews and stories emerge the idea of the mobile home as a way to capitalize on what exists to make the future possible. These stories leave us with more questions. How do these families meet the challenges faced in their neighborhoods? How does the space affect the lives of the people who live here? Where is the escape route for these families when the real estate market imposes its rule in the city? Who is there to protect them? What institutions are ready to step in to help? What public institutions have stepped in to offer an escape from the predatory market?

All these dynamics of multiple social microcosms and individual stories in the mobile homes are enacted in the midst of urban spaces undergoing profound transformation—shattering dreams, accelerating marginalization, and excluding others from the right to inhabit the city. Since the coinage of the term "right to the city" by David Harvey (following Henri Lefebvre's *Le droit à la ville* [1968]), the configuration of urbanization has shifted dramatically, and during the latter decade, in South Florida and Miami-Dade County in particular, the "right to the city" can be seen as a right to the future.[5] What does that mean for these transformed

spaces? What do these futures look like, what is in them? What does it mean for the excluded?

Furthermore, the mobile house is also influenced by the history of colonialism and racial oppression that forces people to be on the move within the United States and beyond its borders. Migration from the southern border and the forced displacement of Indigenous communities, for example, have disrupted the cultural connection between people and their homes. In recent years, human sufferings have intensified in countries in the Caribbean and South and Central America, compounded by the COVID-19 pandemic and its aftermath.[6] These processes have consolidated increasing inequality, violence, political instability, and climate change, which have deep historical roots in colonial regimes of subjugations, predatory extractive capitalisms in Latin America and the Caribbean, and are exacerbated by past and present US foreign policy.[7] In this context, the mobile home/house has become a site of struggle and resistance against oppressive forces, and its meaning can be infused with political and cultural symbolism within and beyond the borders of the United States.

The visualization of the house as social and physical reality in perpetual creation and reframing offers a new way to look at the inherent challenges associated with the human experience in creating sociocultural and built environments. As a material entity, the mobile home is a witness to the appearance of sociocultural worlds where individuals can no longer afford housing in the city. The pictures of condominiums devouring entire mobile home parks reveals the working of economic power entities on individuals, and the production of disregard; the pictures function as a site of memory-making, desire, nostalgia, and illusion. This takes us to a larger city scale.

IV.

Why is this book important? Florida has become one of the most popular states for home buyers from Latin America and the Caribbean. However, Florida's popularity has also led to accelerated gentrification, resulting in many neighborhoods being renovated and "redeveloped" at the expense of the excluded; this, in turn, leads to an increase in property values and rent prices, forcing out and displacing low-income tenants, making it challenging for long-term residents to remain in their own neighborhoods. In Miami-Dade County, as in South Florida in general, affordable housing options are scarce, particularly for low-income families and im-

migrant workers. Coastal South Florida in general is highly vulnerable to sea-level rise due to climate change. Minority populations' prospects of right to the city are now caught within a fragmenting web of gentrification forces in elevated neighborhoods where housing values rise and, paradoxically, force displacement and property damage in low-lying neighborhoods. Since the COVID-19 pandemic, this dynamic has boosted the real estate market that, in turn, has exacerbated inequalities in access to affordable housing and further emphasized the critical need for affordable housing initiatives.

In this context, housing is a key political battleground. The mobile home/house can be seen as both a sociological and a moral category—as an unstable nexus where political shifts become reality, a site for the ongoing processes whereby policies are woven into lives. Taking the mobile home/house as at once a built structure, a socioracial class act, a collection of relations, and a node in larger political and economic systems, this book moves across scales to ask how people's lives and worlds are made and remade in relation to the house and housing configurations.

Here the mobile home is not just a place to live. It is a dynamic relation between the familial spaces of the home and the public spaces of the polis. In attending to the mobile home as a cluster of material, symbolic, and world-making practices, this book accounts for people's adaptability within a range of built environments. The mobile home, in this perspective, is empirically and conceptually a privileged space from which to consider the people who inhabit and transform their houses and familial ties, community leaders who demand housing policies, recipients of public housing, and experts charged with devising and implementing housing projects, among others. This is reality from many vantage points.

The book unveils irreconcilable tensions between a cruel past that relentlessly persists in the present, with its unforgivable realities of faded hopes, a cold present displaying the shattered dreams, disposable lives, and wasted potentials, and a future with its "lots" of uncertainties, forced displacement, brutal erasures, and predatory gentrification. It depicts mobile homes and trailers that desperately resist both their disappearance and disappearing past, originally packaged and sold as idyllic futures with unlimited possibilities.

V.

For I Shall Already Have Forgotten You shows how we embrace the naturalness of our ways of inhabiting South Florida's urban landscape; what we choose to see and

ignore; how we relate to each other; and how easy it is for us to forget those left behind. The book aims to bring us to reflect on claims of moral superiority when judging places and cities other than our own. It brings attention to our cold indifference to people's lived space and their rights to exist in their cities. It calls out both our feelings and judgments. In this sense, it provides visual arguments for the plea for a more integrated and human-focused urban landscapes, one that is fair and sustainable. *For I Shall Already Have Forgotten You* conveys a visual message of the creativity and resistance of those to whom the dreams were sold; it is a reminder of why the broken promises of Florida's homes should concern us all.

Notes

1 Douglas S. Massey and Nancy A. Denton, *American Apartheid: Segregation and the Making of the Underclass* (Cambridge, MA: Harvard University Press, 1993); Richard Rothstein, *The Color of Law: A Forgotten History of How Our Government Segregated America* (New York: Liveright Publishing Corporation, 2016).

2 N. D. B. Connolly, *A World More Concrete: Real Estate and the Remaking of Jim Crow South Florida* (Chicago: University of Chicago Press, 2014); Matthew Desmond, *Evicted: Poverty and Profit in the American City* (New York: Crown Publishers, 2016); Marvin Dunn, *Black Miami in the Twentieth Century* (Gainesville: University Press of Florida, 1997).

3 Monika Gosin, *The Racial Politics of Division: Interethnic Struggles for Legitimacy in Multicultural Miami* (Ithaca, NY: Cornell University Press, 2019); Jonathan Rothwell and Douglas S. Massey, "The Effect of Density Zoning on Racial Segregation in US Urban Areas," *Urban Affairs Review* 47, no. 6 (2011): 861–88.

4 Rothwell and Massey, "Effect of Density Zoning on Racial Segregation"; Louis Herns Marcelin, "Identity, Power, and Socioracial Hierarchies among Haitian Immigrants in Miami-Dade, Florida," in *Neither Enemies Nor Friends: Latinos, Blacks, Afro-Latinos/as*, ed. Anani Dzidzienyo and Suzanne Oboler (New York: Palgrave Macmillan, 2006); Alejandro Portes and Alex Stepick, *City on the Edge: The Transformation of Miami* (Berkeley: University of California Press, 1994).

5 David Harvey, "The Right to the City," *New Left Review* 53 (2008): 23–40; Henri Lefebvre, *Le droit à la ville* (Paris: Editions Anthropos, 1968).

6 Acharya Ashok, *COVID-19: The Global South and the Pandemic's Development Impact*, ed. Pádraig Carmody, Gerard McCann, and Nita Mishra (Bristol, UK: Bristol University Press, 2022).

7 Eduardo Galeano, *Open Veins of Latin America: Five Centuries of the Pillage of a Continent* (New York: Monthly Review Press, 1973); Greg Grandin, "The Blood of Guatemala: A History of Race and Nation," *Latin American Perspectives* 30, no. 3 (2003): 109–29; William L. Marcy, *The Politics of Cocaine: How U.S. Foreign Policy Has Created a Thriving Drug Industry in Central and South America* (Chicago: Chicago Review Press, 2010).

Afterword

Precarity of Home

ALPESH KANTILAL PATEL

My experience of leafing through Diego's book on disappearing areas of mobile homes in South Florida, where I lived for a decade, led to a memory of living in another part of Florida—Leesburg, a city in the central part of the state—that took place almost four decades earlier in the mid-1980s.

Specifically, I was reminded of a tornado ripping through Leesburg and destroying a mobile home park, Brittany Estates. Having forgotten many details, I combed through newspapers online to see if I could find more information on the tragedy. An article in the *Orlando Sentinel* titled "Remembering Terror of Tornado" indicates that the tornado was part of the wrath of Hurricane Elana and had destroyed over two hundred mobile homes.[1] It occurred in August 1985, when I was a month shy of turning eleven. Miraculously, there were no fatalities. This is partly because many homeowners lived there only part-time and were in the northern states. The journalist wrote, "Many mobile homes were so badly damaged that it was hard for insurance agents to tell which was which. A few had simply disappeared."[2] I am especially struck by the reporter's note that a few had "simply disappeared" because I realized that when growing up that my views of Brittany Estates were always from a moving car. They were ephemeral glimpses and obscured, given that the mobile homes are situated slightly off the main highway. Ironically, Brittany Estates had never really "appeared" for me, but they remain lodged in my memory banks four decades later.

As a point of departure, one way to characterize this mobile home complex is through the often cited yet abstract and ill-defined concept of Michel Foucault: heterotopia.[3] Broadly speaking, the concept refers to a space that has its own in-

ternal logic. Foucault writes that one of the first underlying principles of the heterotopia is a space defined by "crisis." By this, he means spaces organized around radical shifts in the body: everything from menstruation and puberty to aging. An example he gives is a boarding school. Foucault further notes that these heterotopias have now been largely replaced by ones characterized by deviation from a societal norm. An example he gives is a psychiatric facility. Foucault suggests that retirement homes fall between these two umbrella categories: "Old age is a crisis, but is also a deviation since in our society, where leisure is the rule, idleness is a sort of deviation."[4] Since Brittany Estates is a retirement home—residents must be age fifty-five and older—it can be understood as an example of a space typified by crisis and deviation.

At the same time, by the 1970s in the United States, as the advertisements Diego reproduces illustrate, mobile homes were not exclusively marketed to retirees: the ads beckoned young families to live full-time in Florida, too.

I suspect my connection between my memories of Leesburg and the subject of Diego's work speaks more broadly to my anxieties about "home." My family of South Asian ancestry moved from England, where I was born, to the United States in 1979. We lived in Anaheim, California, and moved in 1983 when I was nine to Leesburg, where I graduated from high school. As an immigrant, my sense of "home" was always fractured.

Moreover, we lived in modest apartments, which were meant to be temporary until my parents saved enough money to buy a house (which they eventually would by the late 1980s). Then again, my sense of being out of step with the world where I resided can also be about being an adolescent, a "crisis" stage per Foucault.

Finally, it is worth pointing out that I was also wrestling with my sexuality, which I internalized at that time as a deviance of another kind. While homophobia is something I experienced both in and outside of the home, in many ways the domestic situation felt a bit more compromising. The expectation was that I would have an arranged marriage, as my brother and all twelve of my cousins around my age would eventually have.

I suggest that Diego's work is not only about a (vanishing) place but a felt experience or affective condition, specifically a commingling of nostalgia and anxiety—in my case, one that manifested as a connection to being part of the South Asian diaspora, ironically a homeland in which I have never lived; residing in apartments that were more like spaces to wait in for something better; and living in a home that was not reconcilable with my homosexuality.

I want to shift back to the recent present and South Florida while not losing the thread of discussing "home." I found an article about another mobile home park tragedy—this one in east Naples, a city bordering the Gulf Coast in South Florida.[5] It was connected to Hurricane Ian in 2022. In sharp contrast to Brittany Estates, the denizens of these homes live there year-round and are primarily recent immigrants. The article suggests that many were fearful that owners of the land on which the trailer park owners paid rent would use the hurricane to raise the rent or force them out. Here is a heterotopia of crisis born not of age but of the precarity of citizenship: many residents are undocumented, fleeing from hostile political conditions in Central and South America.

Overall, Diego's book captures a specific kind of precarious affective position, and I would argue that his work is also about a refusal to be erased. There is some comfort in the latter for me.

Notes

1 Wesley Loy, "Remembering Terror of Tornado," *Orlando Sentinel*, October 13, 1987.
2 Loy, "Remembering Terror."
3 Michel Foucault, "Des Espaces Autres," *Architecture, Mouvement, Continuité*, no. 5 (October 1984): 46–49.
4 Foucault, "Espaces Autres."
5 Kate Payne, "Hurricane Ian Shows Vulnerability of Trailer Parks and the Immigrant Families Who Call Them Home," *WUSF Public Media*, October 26, 2022, https://wusfnews.wusf.usf.edu/local-state/2022-10-26/hurricane-ian-shows-vulnerability-of-trailer-parks-and-the-immigrant-families-who-call-them-home.

ACKNOWLEDGMENTS

Dr. Alpesh Patel

Dr. Amy Galpin

Dr. Louis Herns Marcelin

Lissette Schaeffler

Claudio Nolasco

Mirta del Valle

Special thanks to

Brad Zellar

Christian Patterson

Chris McCall

CONTRIBUTORS

Amy Galpin is executive director of the Museum of Art and Design, Miami Dade College. She has published over fifteen exhibition catalogs as well as articles in scholarly journals such as *American Art Review* and general media such as the *Washington Post.* She earned her PhD in art history from the University of Illinois-Chicago.

Louis Herns Marcelin is professor of anthropology at the University of Miami, where he is also associate dean for program development. He has published extensively in scholarly journals such as *American Journal of Public Health*, *American Anthropologist*, and the *Journal of Loss and Trauma*. He earned his PhD from the Universidade Federal Rio de Janeiro, Brazil.

Alpesh Kantilal Patel is associate professor of contemporary art at Temple University. In 2023, he is also curator at large for UrbanGlass, Brooklyn, where he is creating a series of exhibitions under the theme "Forever Becoming: Decolonization, Materiality, and Trans* Subjectivity." He is author of *Productive Failure: Writing Queer Transnational South Asian Art Histories* (Manchester University Press, 2017), editor of several volumes, and author of many scholarly articles. He earned his PhD from the University of Manchester.

Buenos Aires–born, Miami-based Diego Alejandro Waisman is a visual artist that explores themes of social and economic displacement, exile, family, identity, and origins. Much of his work revolves around the post-memories of his family diaspora and his journey as an immigrant to the United States. In 2022, Diego received the Green Space grant, and the 30th Annual Emerald Coast National Best-in-Show organized by the Northwestern Florida State College.

 He has received an arts scholarship from the Berkowitz Contemporary Foundation, a visual arts scholarship from Florida International University, as well as the Faena Art Curatorial Studies Scholarship. He holds an animation degree from the Art Institute of Pittsburgh, a studio art degree from the University of Miami, and an MFA from Florida International University.